Compliments of the Chef

Great recipes from great restaurants

Los Angeles

Compliments of the Chef

Great recipes from great restaurants

Los Angeles

Compiled by
Vanessa Frank

Tallfellow Press
Los Angeles

Published by
Tallfellow Press, Inc.
1180 S. Beverly Drive
Los Angeles, CA 90035

Photographs by Robert Lerstrand

Designed by SunDried Penguin Design

ISBN 1-931290-06-7
Printed in Thailand
1 3 5 7 9 10 8 6 4 2

Acknowledgments

Very rarely do we stop and take a moment to appreciate the fact that we have food at our table. Sadly, for many people their pangs of hunger are a constant reminder of their misfortune. In appreciation for all that I am blessed with, I was inspired to create this project.

I would like to express my gratitude to the Los Angeles Regional Foodbank for providing me with an opportunity to make a difference. Its contribution to our society is remarkable and I am confident that all the proceeds raised from the sales of this book will be put to great use.

Without the participation of the talented chefs highlighted in this book, my project would be incomplete. Many thanks for all your time and generosity. A special thanks to Robert Lerstrand, who beautifully captured my vision in his photographs. I would like to thank my test kitchen: Rachel and Jonathan Davis Jr., Carol and Adam Wetsman, Ima, Heather and Celina. An extra special thank you to Darryl, who constantly provides me with endless love and support.

This book is dedicated to Stella—may she embrace the concept of charity throughout her life.

Los Angeles Regional Foodbank
Frequently Asked Questions

WHAT IS THE LOS ANGELES REGIONAL FOODBANK?

The Los Angeles Regional Foodbank is a private, nonprofit, charitable organization that obtains millions of pounds of surplus food that would otherwise go to waste and channels it to hundreds of thousands of hungry and needy people throughout Los Angeles County. The Los Angeles Regional Foodbank is a member of the America's Second Harvest national food bank network and is the only America's Second Harvest food bank in Los Angeles County.

WHERE AND HOW DOES THE LOS ANGELES REGIONAL FOODBANK OBTAIN FOOD?

The Foodbank actively solicits and receives donations of surplus product from all sectors of the food industry: growers, packers, processors, manufacturers, wholesalers, brokers and retailers. Food is donated for a variety of reasons: production errors, sluggish sales, mislabeling and cosmetic defects that do not affect edibility. Additionally, we receive food from organized food drives and individual donations. Through our Extra Helpings Program, we channel prepared food from restaurants, caterers and hotels directly to our charities.

HOW DOES THE LOS ANGELES REGIONAL FOODBANK WORK?

Charities throughout Los Angeles County, such as shelters, food pantries, soup kitchens and senior citizen and childcare centers apply to the Foodbank to become participating charities. Once a member, the charities order and pick up food from the Foodbank once a week. They may also come every afternoon for miscellaneous products if they wish.

WHY IS THE LOS ANGELES REGIONAL FOODBANK IMPORTANT?

Forty-two percent of all households served by the Foodbank have one or more adults working, yet a significant number of families are forced to choose between paying rent and buying groceries. The Los Angeles Regional Foodbank offers a consistent way for charities to provide food to such households, as well as to others who need this support.

Additionally, most charities do not have enough room to store large amounts of donated food. The Foodbank is able to receive, sort and house a great variety of food and other items, allowing the charities the flexibility of selecting only what they need.

HOW CAN I HELP?

You can do many things to support the Foodbank. We are always looking for volunteers and welcome all individuals and groups at our warehouse Monday through Saturday. You can organize a food drive within your company or social group, or donate products individually. Financial contributions are also welcome. Every dollar donated provides $17 worth of food for the hungry in our community. That's a much better deal than you could find at your local supermarket! To learn more about getting involved, contact the Foodbank at 323-234-3030 or visit our Web site at www.lafightshunger.org.

The Mission

The *mission* of the Los Angeles Regional Foodbank is to mobilize the resources of our community to fight hunger, the causes of hunger and the problems related to hunger.

Pasadena resident Tony Collier founded the Los Angeles Regional Foodbank in 1973 as the Grandview Foundation. Collier, a cook, received more food donations from local businesses than he anticipated and shared them with other organizations helping the hungry. Four members of the community, impressed with Collier's work, formed a voluntary Board of Directors to create the Foodbank.

From its humble beginnings in a two-car garage, the Foodbank has grown into the second largest organization of its kind in the nation. Today, through a network of 940 Los Angeles County charities, food is distributed to abused and abandoned children, battered women, the elderly, the disabled, the homeless, the unemployed, those afflicted with AIDS and the working poor. Over 325,000 people are served each week.

In order to utilize the services of the Los Angeles Regional Foodbank, charities must be nonprofit, tax-exempt organizations. To be a participating member, charities must agree to give food received from the Foodbank to needy individuals and must also agree to be monitored by the Foodbank annually.

Contents

Appetizers

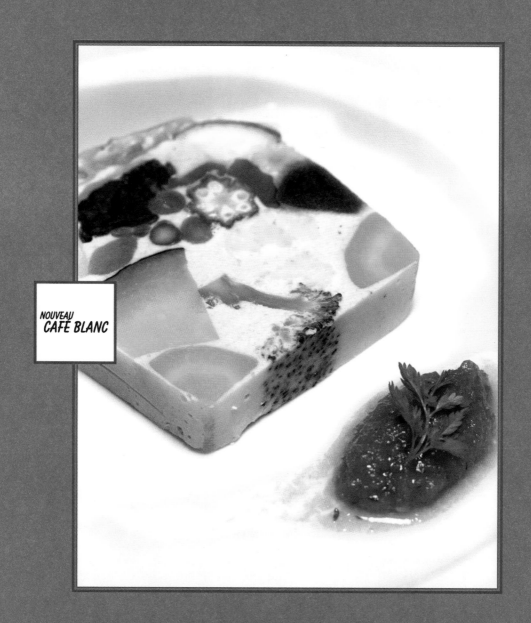

NOUVEAU
CAFÉ BLANC

14

14 Kinds of Vegetables and Smoked Ham Mousse Terrine

SERVES 10

Mousse:

8 oz smoked ham

1 cup heavy cream

1 1/2 Tbs gelatin powder

1/3 cup white wine

1 carrot

1 zucchini

10 small broccoli crowns

10 small cauliflower crowns

1 red bell pepper

1/2 bunch spinach

2 celery stalks

2 asparagus spears

6 pieces okra

1 potato

1 turnip

1/4 kabocha squash

6 baby corns

3 cabbage leaves

Tomato fondue sauce:

2 ripe tomatoes

1/2 onion, chopped

Garlic, chopped

1 Whip 4 oz of heavy cream to 80%. Put the remaining heavy cream in a saucepan with chopped ham. Bring it to a boil. Season with salt and pepper.

2 Mix the white wine and gelatin powder. In a blender, add the ham mixture and wine-gelatin mixture. Mix well. Pour in a bowl and let cool. Slowly add the whipped heavy cream.

3 Boil each vegetable until cooked but still crunchy. Immediately immerse in ice water to keep the color.

4 Layer the vegetables and mousse into a mold, little by little. Refrigerate for at least 3 hours.

5 To prepare sauce: Blanch tomatoes, peel the skin, take out all seeds and dice. Sauté the onion and garlic in olive oil—do not brown. Add the tomato and cook with salt and pepper. Allow to cool.

6 Take the whole terrine out of the mold and slice. Serve with sauce.

Getting Personal
Tomi Harase, Executive Chef/Proprietor

WHAT ARE FIVE HOME PANTRY STAPLES?
Salt, pepper, dry seaweed, soy sauce and sesame oil

WHAT IS YOUR FAVORITE SONG/MUSICIAN TO UNWIND TO?
None

IF YOU HAD 15 MINUTES TO PREPARE DINNER FOR GUESTS AT YOUR HOME, WHAT WOULD YOU PREPARE?
Spaghetti with fresh tomato

WHAT IS YOUR TYPICAL BREAKFAST?
Rice balls

WHAT IS YOUR FAVORITE SNACK?
Shrimp crackers

HOW DO YOU UNWIND AFTER A LONG STINT IN THE KITCHEN?
Having beer with the kitchen staff

WHAT IS YOUR FAVORITE AROMA IN THE KITCHEN?
Rosemary

IF YOU ONLY HAD $10 TO PURCHASE INGREDIENTS FOR DINNER FOR TWO, WHAT WOULD YOU MAKE?
Buckwheat noodles

WHAT IS YOUR STANDARD COMFORT FOOD?
Any good soup

WHAT IS YOUR LEAST-FAVORED VEGETABLE?
Sugar cane

Word to the Wise:

Prior to cooking fish, it is always good to

immerse the fish in milk for a while.

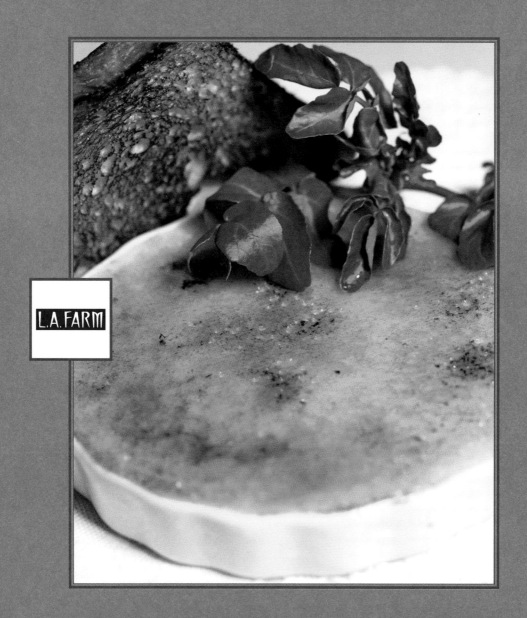

Crème Brulee of Foie Gras

SERVES 4

6 oz goose liver, raw

1 cup cream

1 egg

1 pinch salt and pepper

4 slices white bread, toasted

1 tsp brown sugar

1 truffle

1 Preheat oven to 325°. Slice the truffle into thin slices and distribute equally in 4 crème brulee dishes.

2 In a blender, mix the goose liver, cream, egg, salt and pepper to a creamy consistency.

3 Pour the mixture in 4 dishes. Place in a Bain Marie (large casserole dish filled with water) and bake at 325° for 16 minutes. Place in refrigerator and cool completely.

4 Before serving, cover with a very thin coat of brown sugar and burn rapidly with a torch. Serve with a slice of toasted bread or brioche.

Getting Personal
Jean-Pierre Peiny, Executive Chef

WHAT ARE FIVE HOME PANTRY STAPLES?
Olive oil, garlic, peppercorns, balsamic vinegar and soy sauce

WHAT IS YOUR FAVORITE SONG/MUSICIAN TO UNWIND TO?
Keiku Matsui, the pianist

IF YOU HAD 15 MINUTES TO PREPARE DINNER FOR GUESTS AT
YOUR HOME, WHAT WOULD YOU PREPARE?
Tuna tartar

WHAT IS YOUR TYPICAL BREAKFAST?
Café au lait and fresh baguette with butter and blackberry jam

WHAT IS YOUR FAVORITE SNACK?
SkyFlakes crackers and Osetra caviar

HOW DO YOU UNWIND AFTER A LONG STINT IN THE KITCHEN?
Listen to classical piano

WHAT IS YOUR FAVORITE AROMA IN THE KITCHEN?
Saffron

IF YOU ONLY HAD $10 TO PURCHASE INGREDIENTS FOR DINNER
FOR TWO, WHAT WOULD YOU MAKE?
Tofu salad

WHAT IS YOUR STANDARD COMFORT FOOD?
Crab with tamarind sauce—Vietnamese

WHAT IS YOUR LEAST-FAVORED VEGETABLE?
Bok choy

Word
to the
Wise:

Wait at least 20 minutes after cooking

before eating any roasted meat.

Meat will be more tender then.

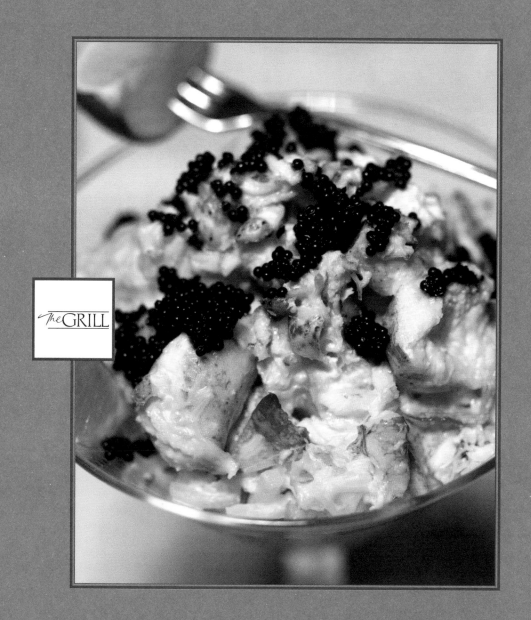

Lobster Martini with Caviar

For each serving:

5 oz lobster meat mix

1 cup celery root remoulade

1 tsp black lumpfish caviar

2 lime wedges

1 martini glass, 8 oz

Kosher salt to taste

Lobster meat mix:

2 lb Maine lobster meat
 (knuckles and claws)

1 1/2 Tbs lime juice

1/2 cup Akavit dressing

Akavit dressing:

1 cup mayonnaise

1 cup sour cream

3 Tbs Akavit Liquor

1 tsp hot sauce

1 tsp lemon juice

Celery root remoulade:

6 cups celery root

1/2 cup mayonnaise

1/2 cup sour cream

1/2 cup red onions, finely chopped

1/4 cup chives

1 To prepare Akavit dressing: Combine all ingredients in a bowl and mix until well blended. Salt to taste.

2 To prepare lobster meat mix: Combine the lobster meat with the lime juice and Akavit dressing.

3 To prepare remoulade: Mix all ingredients together. It should not be wet looking or feeling. Add Kosher salt and hot sauce to taste.

4 Place the remoulade in the martini glasses. Add lobster meat mix on top of remoulade and then top with the caviar. Place 1 lime wedge halfway down each glass and serve the other wedge with a cocktail fork.

Getting Personal
John Sola, VP Executive Chef

WHAT ARE FIVE HOME PANTRY STAPLES?
 Cheese, onion, corn tortillas, olive oil and pasta

WHAT IS YOUR FAVORITE SONG/MUSICIAN TO UNWIND TO?
 Steve Winwood

IF YOU HAD 15 MINUTES TO PREPARE DINNER FOR GUESTS AT YOUR HOME, WHAT WOULD YOU PREPARE?
 Pasta with seafood

WHAT IS YOUR TYPICAL BREAKFAST?
 A cup of tea

WHAT IS YOUR FAVORITE SNACK?
 Sliced Italian salami

HOW DO YOU UNWIND AFTER A LONG STINT IN THE KITCHEN?
 A cigar with a martini

WHAT IS YOUR FAVORITE AROMA IN THE KITCHEN?
 Garlic

IF YOU ONLY HAD $10 TO PURCHASE INGREDIENTS FOR DINNER FOR TWO, WHAT WOULD YOU MAKE?
 Salad with fresh crab

WHAT IS YOUR STANDARD COMFORT FOOD?
 Pasta

WHAT IS YOUR LEAST-FAVORED VEGETABLE?
 Beets

Word to the Wise:

When cooling pasta, do not wash with cold water—

but toss in olive oil and cool in the refrigerator.

Rock Lobster with Cinnamon Butter, Vermicelli and Clams

SERVES 4

16 rock lobsters

8 Manila clams, cleaned and
cooked in salted water

3 1/2 oz vermicelli pasta, cooked
al dente and well drained

3 Tbs butter

1/2 cup lobster stock, greatly reduced

Oil for deep-frying

Cinnamon butter:

1 1/4 cup white wine

2 shallots, finely diced

3 1/2 oz cold butter

2 tsp cinnamon

Salt

1 Shell and de-vein the rock lobster. Shell and clean clams.

2 Deep-fry the vermicelli in hot oil.

3 Combine the butter, lobster stock and clams in a pan and bring to a boil. Add the vermicelli and shake the pan vigorously to coat the noodles with liquid. Keep warm.

4 To prepare the cinnamon butter: Combine shallots and wine in a pot and reduce to 2 Tbs. Strain mixture and return the reduction back to the pot. Whisk in butter in small pieces. Add the cinnamon and season with salt.

5 Rub the rock lobster with salt and pepper and brush with oil. Grill for 1 minute on each side.

6 Press vermicelli into 4 small round servings on pre-warmed plates. Arrange the rock lobster on top and douse with cinnamon butter.

Getting Personal
Ludovic Lefebvre, Executive Chef

WHAT ARE FIVE HOME PANTRY STAPLES?
Olive oil, stock (fish, meat and vegetable), Fleur de Sel, spices and vinegar (balsamic, rice and red wine)

WHAT IS YOUR FAVORITE SONG/MUSICIAN TO UNWIND TO?
The Rolling Stones' "Sympathy for the Devil"

IF YOU HAD 15 MINUTES TO PREPARE DINNER FOR GUESTS AT YOUR HOME, WHAT WOULD YOU PREPARE?
Tomato gazpacho, fish and fruit salad

WHAT IS YOUR TYPICAL BREAKFAST?
Toasted bagel with cream cheese and strawberry jam, coffee and fresh-squeezed orange juice

WHAT IS YOUR FAVORITE SNACK?
Cereal with milk

HOW DO YOU UNWIND AFTER A LONG STINT IN THE KITCHEN?
Talk to the customers and inquire if they had a good dinner—sometimes have a glass of wine with them

WHAT IS YOUR FAVORITE AROMA IN THE KITCHEN?
Star anise

IF YOU ONLY HAD $10 TO PURCHASE INGREDIENTS FOR DINNER FOR TWO, WHAT WOULD YOU MAKE?
Carpaccio of broccoli and tomato with olive oil and basil, melon and prosciutto, caramel soufflé and orange salad

WHAT IS YOUR STANDARD COMFORT FOOD?
Create different oils with spices

WHAT IS YOUR LEAST-FAVORED VEGETABLE?
Hearts of palm

Word
to the
Wise:

A good way to cook green vegetables is to first soak them

in ice water for a few minutes before cooking.

Then cook them in boiling water that contains baking soda

and salt. When finished, return the vegetables to ice water.

Seared Tuna
with Japanese Salsa

SERVES 1

1 tsp vegetable oil
6 oz fresh tuna fillet
1/4 red onion, finely chopped
2 cilantro sprigs, finely chopped
1/4 tomato, finely chopped
1 pinch salt and pepper
1/2 avocado, sliced 1/4" thick

Sauce:

1/4 cup soy sauce
1/4 cup rice vinegar
2 tsp sesame oil
1/2 tsp sugar

1 Mix all the ingredients for the sauce. Add the chopped tomato, cilantro and onion.

2 Season the tuna very well with salt and pepper.

3 Heat a pan over high heat and add the vegetable oil. When the oil is hot, sear the tuna for 30 seconds on each side. Remove from heat and slice the tuna in 1/4" slices.

4 To serve, neatly arrange the tuna slices and avocado slices on a plate and drizzle the sauce over the tuna.

Getting Personal
Katsuya Uechi, Executive Chef

WHAT ARE FIVE HOME PANTRY STAPLES?
Rice, soy sauce, flour, bread and miso

WHAT IS YOUR FAVORITE SONG/MUSICIAN TO UNWIND TO?
Billy Joel

IF YOU HAD 15 MINUTES TO PREPARE DINNER FOR GUESTS AT
YOUR HOME, WHAT WOULD YOU PREPARE?
Steak

WHAT IS YOUR TYPICAL BREAKFAST?
Rice, miso soup and broiled fish

WHAT IS YOUR FAVORITE SNACK?
Snickers

HOW DO YOU UNWIND AFTER A LONG STINT IN THE KITCHEN?
Have a cold beer

WHAT IS YOUR FAVORITE AROMA IN THE KITCHEN?
Soy sauce burning

IF YOU ONLY HAD $10 TO PURCHASE INGREDIENTS FOR DINNER
FOR TWO, WHAT WOULD YOU MAKE?
Garlic chicken thighs with a salad

WHAT IS YOUR STANDARD COMFORT FOOD?
Stir-fried vegetables and tofu

WHAT IS YOUR LEAST-FAVORED VEGETABLE?
Celery

Word
to the
Wise:

When cooking steamed rice, always choose

a top-quality brand and wash the rice 3 or 4 times.

When the rice boils, reduce the fire to low and cover for

25 to 30 minutes. Then let it sit for at least 15 minutes.

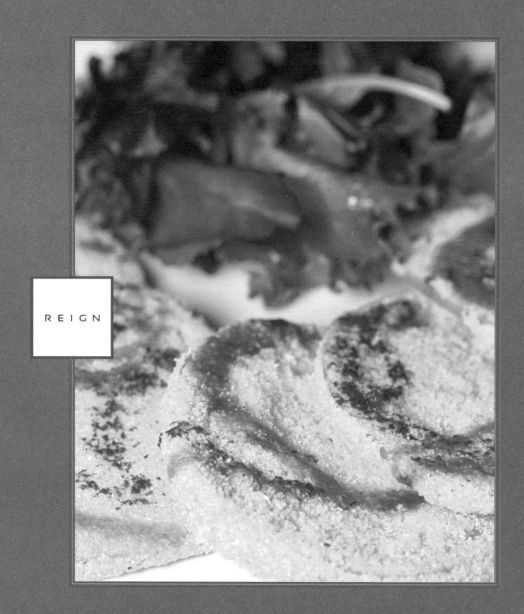

REIGN

Fried Green Tomatoes

SERVES 6

4 organic green tomatoes

2 cups yellow corn meal

1 Tbs Kosher salt

1 Tbs Peppercorn, 24 mesh

1 Tbs garlic salt

1 Tbs Lawry's Seasoned Salt

12 eggs

2 cups milk

5 Tbs canola oil

1 Mix the yellow corn meal with Kosher salt, pepper, garlic salt and Lawry's Seasoned Salt.

2 Whip the eggs. Fold milk into the eggs until creamy.

3 Slice the organic green tomatoes 1/4" thick. Dip into egg batter and bread the green tomatoes in the yellow corn meal mixture.

4 Heat the canola oil in a 10" sauté pan and bring to frying temperature. Delicately place 5–6 tomato slices in the pan and fry for 2 minutes or until golden brown. Turn slices over and repeat.

5 Remove tomatoes from the pan and dry lightly with paper towel.

6 Serve on a bed of mixed green salad. Squirt drips of basil essence and homemade spice sauce on top.

Getting Personal
Michael Rosen, Executive Chef

WHAT ARE FIVE HOME PANTRY STAPLES?
Extra virgin olive oil, garlic, sambal (chili paste), rice and sherry or balsamic vinegar

WHAT IS YOUR FAVORITE SONG/MUSICIAN TO UNWIND TO?
Simply the best—"Night at the Opera"

IF YOU HAD 15 MINUTES TO PREPARE DINNER FOR GUESTS AT YOUR HOME, WHAT WOULD YOU PREPARE?
Pasta primavera, mixed baby green salad, steamed artichokes or asparagus and grilled sausage

WHAT IS YOUR TYPICAL BREAKFAST?
Hot tea, plain organic yogurt and rice with flaxseed oil

WHAT IS YOUR FAVORITE SNACK?
Jumbo roasted and lightly salted cashews

HOW DO YOU UNWIND AFTER A LONG STINT IN THE KITCHEN?
Work on my sons' clubhouse, watch a Kurosawa movie, go fishing

WHAT IS YOUR FAVORITE AROMA IN THE KITCHEN?
Freshly baked apple pie

IF YOU ONLY HAD $10 TO PURCHASE INGREDIENTS FOR DINNER FOR TWO, WHAT WOULD YOU MAKE?
Fried catfish, green salad and steamed white rice with ponzu sauce

WHAT IS YOUR STANDARD COMFORT FOOD?
Macaroni and cheese with extra sharp cheddar

WHAT IS YOUR LEAST-FAVORED VEGETABLE?
Canned vegetables

Word to the Wise:

Make sure your knives are sharp,

use good-quality stainless steel pans

and marry a good cook!

Soups

Gazpacho

SERVES 6–8

1 celery stalk, chopped

1 tomato, cored and quartered

1 small green bell pepper,
 cored and seeded

1 large cucumber or 4 kirbies,
 peeled and chopped

5 garlic cloves, peeled

1–2 small jalapeño peppers,
 seeds optional to taste

2 slices day-old white bread,
 crusts removed

1 can tomato juice, 32 oz

Chopped fresh chives for garnish

Mayonnaise:

3 egg yolks

1 Tbs paprika

2 Tbs tarragon vinegar
 or white wine vinegar

1 1/2 tsp salt

1 cup olive oil

Tabasco sauce to taste

1 Process the celery, tomato, bell pepper, cucumber, garlic, jalapeños and bread in a food processor until fine. Transfer the mixture to a blender and add the tomato juice. Puree until smooth. Strain and set aside.

2 To prepare the mayonnaise: Whisk together the egg yolks, paprika, vinegar and salt in a large bowl. Gradually add the olive oil, one drop at a time. Whisk constantly until an emulsion forms.

3 Add the reserved vegetable puree to the mayonnaise, 1/4 cup at a time. Whisk constantly until it is thoroughly blended. Adjust with Tabasco sauce to desired spiciness. Chill for a minimum of 2 hours.

4 Serve in chilled bowls with a sprinkling of chopped chives.

Getting Personal
Mary Sue Milliken, Co-Chef/Co-Owner

WHAT ARE FIVE HOME PANTRY STAPLES?
> Extra virgin olive oil, Maldon sea salt, pepper mill with Tellicherry black peppercorns, organic yellow split peas and unfiltered cider vinegar

WHAT IS YOUR FAVORITE SONG/MUSICIAN TO UNWIND TO?
> Anything I can sing along with—especially Elvis Costello

IF YOU HAD 15 MINUTES TO PREPARE DINNER FOR GUESTS AT YOUR HOME, WHAT WOULD YOU PREPARE?
> Cheese fondue and salad

WHAT IS YOUR TYPICAL BREAKFAST?
> Salad dressed with whole grain mustard, red wine vinegar, extra virgin olive oil and topped with fried eggs

WHAT IS YOUR FAVORITE SNACK?
> Rice crackers with seaweed

HOW DO YOU UNWIND AFTER A LONG STINT IN THE KITCHEN?
> With a glass of fine red wine

WHAT IS YOUR FAVORITE AROMA IN THE KITCHEN?
> Just-cooked Basmati rice

IF YOU ONLY HAD $10 TO PURCHASE INGREDIENTS FOR DINNER FOR TWO, WHAT WOULD YOU MAKE?
> Yellow split peas stewed with garlic and basil served over crispy-bottomed Basmati rice, seared rainbow trout with leeks, roasted whole tomatoes and goat cheese

WHAT IS YOUR STANDARD COMFORT FOOD?
> Chicken soup

WHAT IS YOUR LEAST-FAVORED VEGETABLE?
> Broccoli because it is overexposed/overused

Word to the Wise:

The best way to not over-dress a salad is to toss it in a bowl

twice the size of your salad. Drizzle dressing over the salad

and use the best tools in the kitchen—your hands. Toss until

each leaf is lightly coated. Drizzle more if necessary.

TRATTORIA
AMiCi

Pasta and Fagioli

SERVES 6–8

*4 cups white Italian canellini
 (or northern) beans, uncooked*

6 cups vegetable broth

2 cups green lentils, uncooked

2 cups shallots, chopped

2 Tbs extra virgin olive oil

1 Tbs fresh sage, chopped

*2 cups fettuccini, chopped
 (uncooked)*

Shaved Parmesan cheese for garnish

1 In a stockpot, sauté the shallots and sage with 1 Tbs olive oil until golden. Add the beans and the lentils and sauté for a few more minutes. Add the vegetable broth. Let the soup come to a boil and reduce the fire to a medium-low flame. Cook the soup for 3 hours or until the beans are very tender.

2 Add the fettuccine and cook for another 5 minutes. Add salt and pepper to taste and serve with the remaining extra virgin olive oil and shaved Parmesan on top.

Getting Personal
Enrico Trova, Executive Chef

WHAT ARE FIVE HOME PANTRY STAPLES?
Extra virgin olive oil, whole peeled tomatoes, pasta,
Kalamata olives and capers

WHAT IS YOUR FAVORITE SONG/MUSICIAN TO UNWIND TO?
Harry Balafonte's "Jump in Line, Shake, Shake Señora"

IF YOU HAD 15 MINUTES TO PREPARE DINNER FOR GUESTS AT
YOUR HOME, WHAT WOULD YOU PREPARE?
Chicken paillard with lemon and caper sauce; mixed baby green
salad with shaved Parmesan cheese and lemon vinaigrette

WHAT IS YOUR TYPICAL BREAKFAST?
Pane e Nutella—bread with Nutella (chocolate-hazelnut) spread

WHAT IS YOUR FAVORITE SNACK?
French baguette with Camembert

HOW DO YOU UNWIND AFTER A LONG STINT IN THE KITCHEN?
Stay in bed and play video games

WHAT IS YOUR FAVORITE AROMA IN THE KITCHEN?
Sautéed garlic and rosemary

IF YOU ONLY HAD $10 TO PURCHASE INGREDIENTS FOR DINNER
FOR TWO, WHAT WOULD YOU MAKE?
Risotto with asparagus and mushrooms

WHAT IS YOUR STANDARD COMFORT FOOD?
Häagen-Dazs Hazelnut gelato

WHAT IS YOUR LEAST-FAVORED VEGETABLE?
Zucchini

Word to the Wise:

To skim the fat from a hot broth or soup, let the broth

settle until the fat comes up. Then apply paper towels directly

on top and allow the paper towels to "suck" the fat. Gently

lift the towels and repeat with new towels until all fat is gone.

Salads

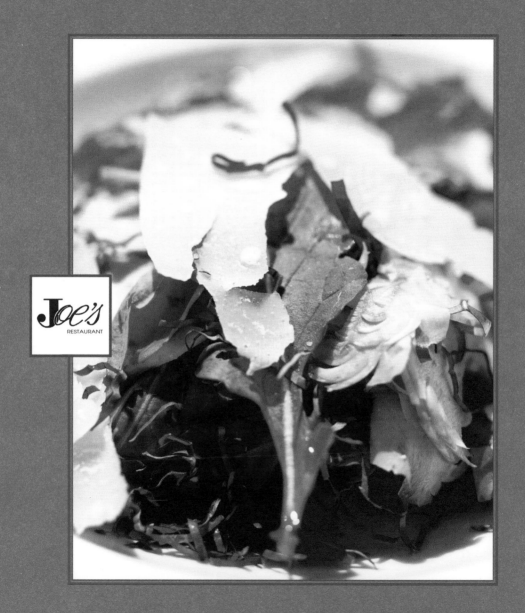

Artichoke Arugula Salad

SERVES 2

2 artichokes, trimmed

1/2 cup arugula

2 Tbs basil, julienned

2 Tbs Kosher salt

1 tsp ground white pepper

1/4 cup Reggiano
 Parmesan cheese, shaved

Basil oil

Lemon vinaigrette:

 (yields 7 1/2 servings)

10 lemons, juiced

2 cups olive oil

2 Tbs Kosher salt

1/2 Tbs white pepper

1 To prepare the vinaigrette: Add the lemon juice, salt and pepper to a blender. While blending, slowly add the olive oil. Taste for seasoning.

2 Trim the artichokes of all green leaves and choke. Immerse in water with lemon, to maintain whiteness.

3 Clean the arugula and dry well. Slice the artichoke as thin as possible. Mix the artichoke with arugula, basil, 3 oz lemon vinaigrette, salt and pepper.

4 Serve in 2 bowls and garnish with shaved Parmesan and basil oil.

Getting Personal
Joe Miller, Executive Chef

WHAT ARE FIVE HOME PANTRY STAPLES?
Santa Barbara olive oil, sea salt, whole white pepper, bay spice and cottage cheese

WHAT IS YOUR FAVORITE SONG/MUSICIAN TO UNWIND TO?
Sting or Van Morrison

IF YOU HAD 15 MINUTES TO PREPARE DINNER FOR GUESTS AT YOUR HOME, WHAT WOULD YOU PREPARE?
Grilled steaks with grilled vegetables and tomato couscous

WHAT IS YOUR TYPICAL BREAKFAST?
Eggs, tomatoes, green onions and grated cheddar cheese

WHAT IS YOUR FAVORITE SNACK?
Yogurt and peanut Balance Bars (nutrition bars)

HOW DO YOU UNWIND AFTER A LONG STINT IN THE KITCHEN?
Read cookbooks

WHAT IS YOUR FAVORITE AROMA IN THE KITCHEN?
Veal stock

IF YOU ONLY HAD $10 TO PURCHASE INGREDIENTS FOR DINNER FOR TWO, WHAT WOULD YOU MAKE?
2 rib-eye steaks, 2 bunches asparagus and 2-egg Béarnaise sauce

WHAT IS YOUR STANDARD COMFORT FOOD?
Roast chicken

WHAT IS YOUR LEAST-FAVORED VEGETABLE?
Broccoli

Word
to the
Wise:

Always season blanched vegetables with salt and pepper.

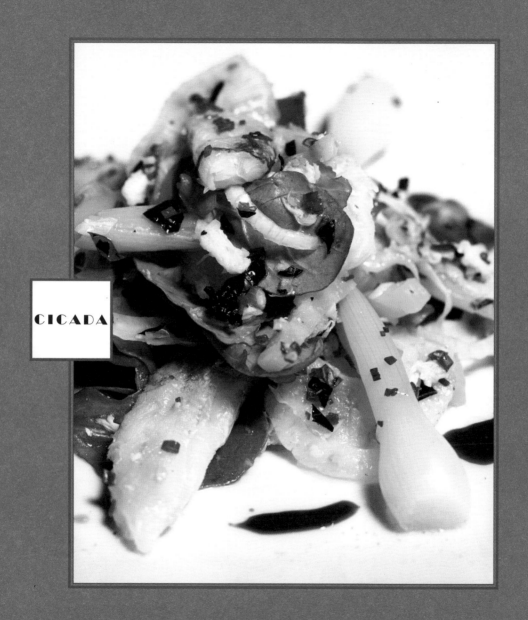

CICADA

Dungeness Crab Salad
with Fennel and Spring Onions

SERVES 4

2 Dungeness crabs, 2 lb each

2 fennel bulbs, trimmed, washed,
 and shaved across grain

12 asparagus spears, blanched

1 cup fresh baby arugula

1 shallot, finely minced

2 Tbs chives, chopped fine

2 Tbs basil, julienned

2 lemons, juiced

6 spring onions,
 halved and braised

2 Tbs Kosher salt

1/4 cup Kosher salt

4 Tbs extra virgin olive oil

Black pepper and
 sea salt to taste

1 Bring 1 gallon of water with 1/4 cup Kosher salt to a boil and add the crabs. Cook
for 7 minutes. On a sheet pan, allow the crabs to cool slightly. Crack the
crabs—first the claws and then the body.

2 Bring 1 quart of water with 2 Tbs Kosher salt to a boil and add the asparagus.
Blanch and remove. Add the halved spring onions to the water and cook until they
are tender. Set aside to cool.

3 Wash the arugula and dry with a salad spinner. Refrigerate.

4 Combine the shaved fennel, minced shallot, chopped chives, julienned basil and crab
meat. Toss with the olive oil, fresh lemon juice, sea salt and pepper. Add the arugula,
asparagus and spring onions. Test for proper seasoning.

Getting Personal
Christian Shaffer, Executive Chef

WHAT ARE FIVE HOME PANTRY STAPLES?
Capers, olive oil, sherry vinegar, sea salt and chestnut honey

WHAT IS YOUR FAVORITE SONG/MUSICIAN TO UNWIND TO?
John Coltrane

IF YOU HAD 15 MINUTES TO PREPARE DINNER FOR GUESTS AT
YOUR HOME, WHAT WOULD YOU PREPARE?
Herb and cheese omelets, asparagus in vinaigrette and s'mores

WHAT IS YOUR TYPICAL BREAKFAST?
A bowl of soup

WHAT IS YOUR FAVORITE SNACK?
Salt and pepper Kettle chips

HOW DO YOU UNWIND AFTER A LONG STINT IN THE KITCHEN?
Knob Creek (bourbon) on the rocks

WHAT IS YOUR FAVORITE AROMA IN THE KITCHEN?
Roasting lamb

IF YOU ONLY HAD $10 TO PURCHASE INGREDIENTS FOR DINNER
FOR TWO, WHAT WOULD YOU MAKE?
Salad lyonnaise and apple tarte tatin

WHAT IS YOUR STANDARD COMFORT FOOD?
Mexican

WHAT IS YOUR LEAST-FAVORED VEGETABLE?
Salsify

Word to the Wise:

Always season each ingredient

throughout the cooking process

to increase depth of flavor.

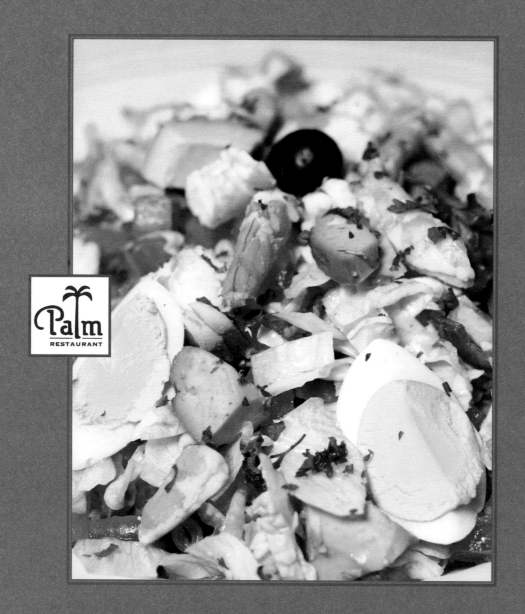

Gigi Salad

3/4 cup tomato, chopped

1/4 cup onion, chopped

3/4 cup green beans,
cooked and chopped

2 cocktail-size shrimp,
cooked and chopped into 1/2" pieces

2 Tbs vinaigrette

2 Tbs bacon bits

1 hard boiled egg, quartered

1/2 avocado, cubed

1 Toss the tomato, green beans, onion, bacon bits and vinaigrette in a bowl.

2 Neatly arrange the avocado and egg on top of the salad.

3 Place the shrimp on top of the entire salad.

Getting Personal

Gigi Delmaestro, General Manager

WHAT ARE FIVE HOME PANTRY STAPLES?
Salt, pepper, olive oil, garlic and basil

WHAT IS YOUR FAVORITE SONG/MUSICIAN TO UNWIND TO?
Frank Sinatra's "New York, New York"

IF YOU HAD 15 MINUTES TO PREPARE DINNER FOR GUESTS AT
YOUR HOME, WHAT WOULD YOU PREPARE?
Pasta with garlic, fresh tomato, olive oil, fresh basil
and Parmesan cheese

WHAT IS YOUR TYPICAL BREAKFAST?
Basic eggs over easy, bacon and hash browns or French toast

WHAT IS YOUR FAVORITE SNACK?
Fruit—cherries, grapes or my favorite, grapefruit

HOW DO YOU UNWIND AFTER A LONG STINT IN THE KITCHEN?
Singing and dancing around. Enjoying the feeling of a hard
day completed and a new day to come tomorrow

WHAT IS YOUR FAVORITE AROMA IN THE KITCHEN?
The aroma of freshly chopped basil and strong but sweet garlic

IF YOU ONLY HAD $10 TO PURCHASE INGREDIENTS FOR DINNER
FOR TWO, WHAT WOULD YOU MAKE?
Baked chicken lightly coated with olive oil, garlic, salt and pepper;
blanched vegetable of the season and mashed potatoes

WHAT IS YOUR STANDARD COMFORT FOOD?
Pasta prepared any way

WHAT IS YOUR LEAST-FAVORED VEGETABLE?
Raw onions

Risotto alla Parmigiana with Piedmontese Beef Fillet Salad

SERVES 2 (IF ENTREE OR 3-4 IF APPETIZER)

Salad:

12 oz Piedmontese beef fillet,
 cut into 4 filet mignons of 3 oz each

2 bunches arugula

16 cherry tomatoes — 8 red and 8 yellow,
 10 halved; reserve 6 for garnish

1 Tbs Worcestershire sauce

6 Tbs extra virgin olive oil

2 Tbs lemon juice

Salt and freshly ground black pepper

Risotto:

12 oz Arborio or Carnaroli rice

2 oz butter

$1/2$ cup white wine

1 Tbs onion, finely chopped

3 Tbs Parmesan cheese, grated

Chicken stock as needed

Salt to taste

1 To prepare the dressing: Place the Worcestershire sauce, olive oil, lemon juice, salt and pepper into a bowl. Whisk energetically until all ingredients emulsify.

2 Clean and wash the arugula and cut in half. Cut the tomatoes lengthwise. Set both aside.

3 Place $1/3$ of the butter and the onion into a relatively small stockpot. Sauté on a low flame until the onion turns golden. Add the rice and mix well for 2–3 minutes. Add the white wine and let evaporate. Add enough chicken stock to cover the rice and a bit of salt and pepper to taste. Constantly stir. Add more chicken stock to cover, when the previous stock is absorbed. Repeat this process and stir constantly until the rice is cooked (approximately 20 minutes).

4 Grill the beef to medium rare and slice into a julienne.

5 In a bowl, mix the beef, arugula, tomatoes and toss with the dressing.

6 Before serving, add the remaining $2/3$ of the butter and the Parmesan cheese to the rice. Mix very well. To serve, place the risotto on a serving plate and put the salad on top of the risotto.

Getting Personal
Giacomino Drago, Executive Chef

WHAT ARE FIVE HOME PANTRY STAPLES?
Olive oil, salt, garlic, red wine vinegar and dried pasta

WHAT IS YOUR FAVORITE SONG/MUSICIAN TO UNWIND TO?
Frank Sinatra

IF YOU HAD 15 MINUTES TO PREPARE DINNER FOR GUESTS AT
YOUR HOME, WHAT WOULD YOU PREPARE?
Arugula salad and pasta with tomato and basil

WHAT IS YOUR TYPICAL BREAKFAST?
Toast with strawberry jam

WHAT IS YOUR FAVORITE SNACK?
Apple tart with crème caramel and vanilla ice cream

HOW DO YOU UNWIND AFTER A LONG STINT IN THE KITCHEN?
Having a glass of wine

WHAT IS YOUR FAVORITE AROMA IN THE KITCHEN?
Rosemary

IF YOU ONLY HAD $10 TO PURCHASE INGREDIENTS FOR DINNER
FOR TWO, WHAT WOULD YOU MAKE?
Tomato and cucumber salad, spinach and pea risotto

WHAT IS YOUR STANDARD COMFORT FOOD?
Spaghetti with tomato and basil

WHAT IS YOUR LEAST-FAVORED VEGETABLE?
Zucchini

Word to the Wise:

When adding extra virgin olive oil to pasta right

before serving—do not heat the olive oil—

but add it at room temperature.

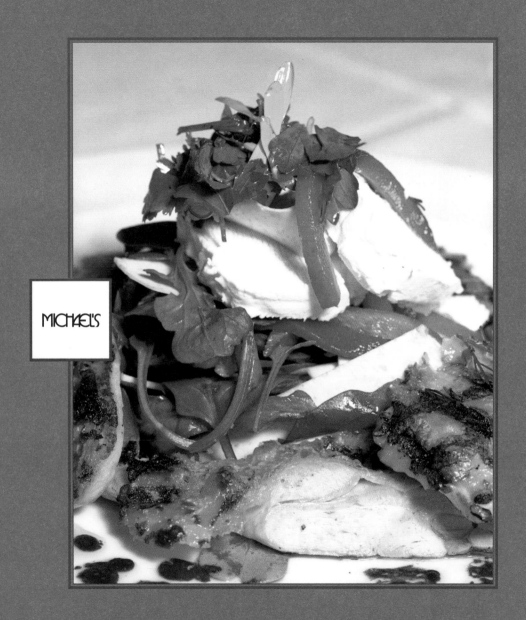

MICHAEL'S

66

Grilled Chicken and Goat Cheese Salad with Jalapeño-Cilantro-Lime Salsa

SERVES 6

- 6 chicken breast halves, boned, skin on and wings attached
- 1 creamy white California goat cheese, 12 oz log, cut into 1/4" medallions
- Salt and freshly ground black pepper
- 3 each red and yellow bell peppers, stemmed, seeded and cut into 3/4–1" slices
- 1 large sweet onion, peeled and cut into 3/8" slices
- 2 Tbs extra virgin olive oil

Wash, dry and tear:
- 3 heads limestone lettuce
- 3 bunches mache
- 2 bunches arugula
- 2 heads baby red leaf lettuce
- 1 head radicchio, separated
- 1 bunch fresh chives, chopped

Tomato Concasse:
- 2 medium tomatoes
- 1/2 cup extra virgin olive oil
- 1/8 cup sherry wine vinegar
- 1/4 medium shallot, finely chopped
- 1 Tbs fresh basil, julienned
- Salt and freshly ground white pepper

Balsamic Vinaigrette:
- 1/3 cup balsamic vinegar
- 2/3 cup extra virgin olive oil
- Fresh lime juice
- Salt and freshly ground white pepper

Jalapeño-Cilantro-Lime Salsa:
- 2 jalapeño peppers, roasted, peeled, seeded and chopped
- 2 Tbs cilantro leaves, chopped
- 1 cup extra virgin olive oil
- Salt and freshly ground white pepper
- 2 limes, halved

1 Preheat grill. With your finger, gently make a pocket between the skin and meat of each chicken breast. Insert the cheese, overlapping slightly, inside the pockets of the chicken. Add salt and pepper.

2 Brush the bell peppers and onion with the olive oil and season with salt and pepper. Set aside.

3 Grill the chicken, skin-side up first, until browned, 3–5 minutes. Flip and grill for another 5–7 minutes.

CONTINUED ON NEXT PAGE

Grilled Chicken and Goat Cheese Salad with Jalapeño-Cilantro-Lime Salsa

4 Grill the bell peppers and onion about 30 seconds per sides, until heated through and lightly charred.

5 Arrange all the salad leaves on 6 plates. Cut each breast crosswise into 4–5 slices and place in the center of greens. Garnish each plate with 3 spoonfuls of concasse, peppers and onions. Dress the vegetables with the vinaigrette. Spoon the salsa over the chicken. Top each serving with chives.

6 To prepare concasse: Bring a large saucepan of water to a boil. Cut out the stem ends and cores of the tomatoes; cut a shallow X on the bottom. Boil the tomatoes until their skins are loose, about 40 seconds. With a slotted spoon, transfer them to a bowl of ice water. After a minute, peel off the tomato skins. Cut them in half through their stem ends. Remove their seeds, then dice into 1/4" pieces. Put in a bowl with the olive oil, vinegar, shallot and basil. Season to taste with salt and pepper and toss. Cover and chill in the refrigerator for at least 30 minutes.

7 To prepare vinaigrette: Put the vinegar in a mixing bowl and, whisking continually, gradually pour in the olive oil. Season to taste with a little lime juice, salt and pepper.

8 To prepare salsa: In a bowl, stir together the jalapeños, cilantro and olive oil. Season to taste with salt and pepper. Just before serving, squeeze the lime into the mixture and stir well. (The lime juice will turn the cilantro brown if added any earlier.)

Getting Personal
Michael McCarty, Executive Chef

WHAT ARE FIVE HOME PANTRY STAPLES?
Bay's English muffins, Skippy crunchy peanut butter,
Land O' Lakes salted butter, Smuckers strawberry
preserves and salad material

WHAT IS YOUR FAVORITE SONG/MUSICIAN TO UNWIND TO?
"Eat That Chicken" or "The Revolution Will Not Be Televised"
by Gil Scott Heron

IF YOU HAD 15 MINUTES TO PREPARE DINNER FOR GUESTS AT
YOUR HOME, WHAT WOULD YOU PREPARE?
Grilled prime rib eye, grilled vegetables, Kim's mixed green salad
and Häagen-Dazs Dulce de Leche ice cream

WHAT IS YOUR TYPICAL BREAKFAST?
Cheerios, whole milk and sliced bananas

HOW DO YOU UNWIND AFTER A LONG STINT IN THE KITCHEN?
In my Jacuzzi on the deck overlooking the Pacific Ocean amidst my
vineyard—"The Malibu Vineyard"; wine from this vineyard is sold at
Michael's in Santa Monica and NYC, as well as a few retail locations
in Southern California

WHAT IS YOUR FAVORITE AROMA IN THE KITCHEN?
Roast chicken with thyme

IF YOU ONLY HAD $10 TO PURCHASE INGREDIENTS FOR DINNER
FOR TWO, WHAT WOULD YOU MAKE?
Chicken and goat cheese salad

WHAT IS YOUR STANDARD COMFORT FOOD?
Bay's English muffin (toasted), Skippy crunchy peanut butter
and Smucker's strawberry preserves enjoyed with a large glass
of whole milk

WHAT IS YOUR LEAST-FAVORED VEGETABLE?
Never met a vegetable I didn't like

Word
to the
Wise:

Prior to spreading peanut butter on a Bay's English muffin

or bread of choice, always spread a layer of

Land O' Lakes butter. The butter allows

the peanut butter to glide easily onto the muffin or bread.

Entrees

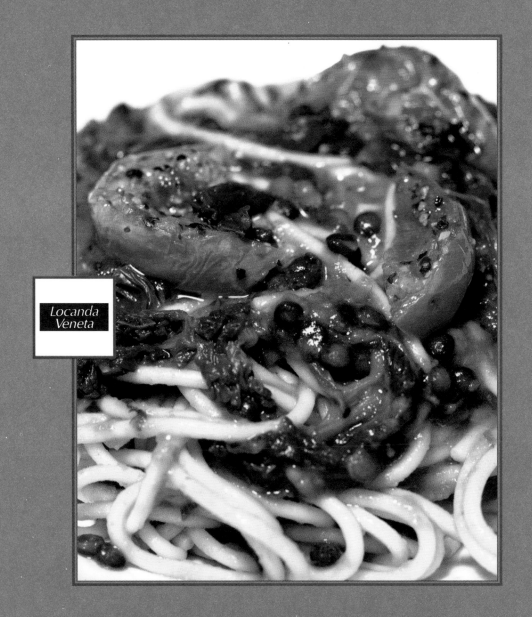

Locanda
Veneta

Spaghetti with Spinach, Oven-Roasted Tomatoes and Lentils

SERVES 6

1 1/2 lb spaghetti, uncooked

10 oz dry lentils

1 lb fresh spinach

6 ripe Roma tomatoes

1 small bunch Italian parsley, chopped

1/3 cup extra virgin olive oil

Pinch of dried oregano

2 garlic cloves, chopped

1 small carrot

1 celery stalk

1 medium red onion

Salt and pepper

1 Preheat oven to 450°.

2 Rinse the lentils and soak in water for 2 hours.

3 Clean and steam the spinach. Drain well and squeeze out remaining excess water.

4 Chop the carrot, onion and celery very finely. Put in a pan with 1/3 cup olive oil. Braise until it reaches a golden color. Add the lentils and water—have the water 2–3 inches above the level of the lentils. Cook until lentils are al dente (approximately 20 minutes).

5 Cut the tomatoes in half and put them on a baking pan—cut side up. Sprinkle with salt, pepper, parsley, garlic, oregano and some olive oil. Roast in the oven at 450° for 20–30 minutes.

6 Put 1 tsp olive oil in the pan and heat it up. Add the steamed spinach and tomatoes. Sauté over high heat for 1 minute. Add the lentils and cook for a few minutes.

7 Boil the spaghetti in salted water until it's al dente. Strain the spaghetti and pour into the pan with the lentil mixture—cook for 1 minute. If desired, add a bit of butter and grated Parmesan cheese while cooking.

Getting Personal
Massimo Ormani, Executive Chef

WHAT ARE FIVE HOME PANTRY STAPLES?
Pasta, Arborio rice, dried cannellini beans, Capezzana extra
virgin olive oil and a strong red wine vinegar that my father makes
in Tuscany

WHAT IS YOUR FAVORITE SONG/MUSICIAN TO UNWIND TO?
Puccini or Beethoven for hearty Italian; Tito Puente for a spicy meal;
Pink Floyd for a delicate pastry job. It's all about inspiration!!

IF YOU HAD 15 MINUTES TO PREPARE DINNER FOR GUESTS AT
YOUR HOME, WHAT WOULD YOU PREPARE?
Bruschetta with fresh tomato and good olive oil, and spaghetti
with clams and white wine sauce

WHAT IS YOUR TYPICAL BREAKFAST?
Milk and whole grain oat cereal—what else?!

WHAT IS YOUR FAVORITE SNACK?
Regular glazed Krispy Kreme doughnuts—the most addictive
food on earth

HOW DO YOU UNWIND AFTER A LONG STINT IN THE KITCHEN?
4 miles in 30 minutes on the treadmill after serving lunch;
at the end of the day: carpaccio and a beer and getting
home in time to watch "Nightline" with my lovely wife

WHAT IS YOUR FAVORITE AROMA IN THE KITCHEN?
The smell of homemade cereal cookies baking in the oven

IF YOU ONLY HAD $10 TO PURCHASE INGREDIENTS FOR DINNER
FOR TWO, WHAT WOULD YOU MAKE?
Pasta e fagioli—it's tasty, filling, healthy and inexpensive

WHAT IS YOUR STANDARD COMFORT FOOD?
My mother-in-law's matzo ball soup

WHAT IS YOUR LEAST-FAVORED VEGETABLE?
Pumpkin

Word
to the
Wise:

For better bruschetta, punch a hole in the tomato with your

thumb and rub it on toasted garlic bread— letting the juice

soak the bread. Top the bread with shredded pieces of remaining

tomato, salt and pepper and drizzle with abundant tasty olive oil.

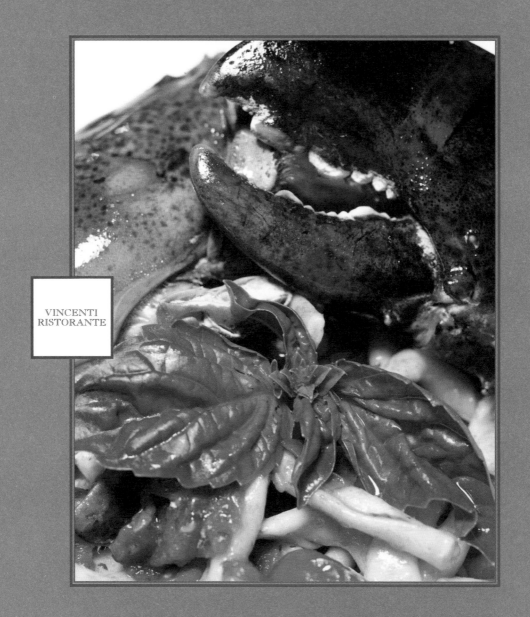

VINCENTI
RISTORANTE

Strozzapretti with Lobster Ragu

SERVES 6

Strozzapretti:

1 1/8 cup flour

5 oz water

1 tsp salt

Lobster ragu:

2 lobsters, 1 lb each

1 shallot, white part only, chopped

4 basil leaves

1/2 cup cognac

6–7 Tbs extra virgin olive oil

1/2 lb cherry tomatoes, quartered

Salt and red chili flakes to taste

Chopped parsley for garnish

Chopped basil leaves for garnish

1 To prepare strozzapretti: Place the flour on a working surface and slowly add salt and water—about 5 oz. Work the dough until it becomes uniform. Run the dough through a pasta machine or roll it out into a sheet. Cut the dough into 1/2" wide slices of 12" strips. Roll the slices in between your palms to make a rope-like strand. Pinch off 3" in length of the dough as you continue down the strand. For each strand, you will have 4 smaller pieces.

2 Bring water to a boil and cook the lobsters for 3 minutes and allow them to cool. When cool, remove the lobster meat and cut into pieces.

3 Heat a sauté pan on a low flame. Add the extra virgin olive oil and shallot. Sauté until the shallot is somewhat soft. Raise to a high flame and add the basil and lobster meat. Add the cognac and allow it to evaporate. Add the tomatoes and cook for about 5 minutes. Add salt and red chili flakes to taste.

4 Bring enough salted water to a boil to cook the pasta. Add the strozzapretti and cook for 3 minutes. Drain the strozzapretti and add to the lobster ragu in the sauté pan. Heat for one minute and transfer to 6 plates, adding the chopped parsley and basil as garnish.

Getting Personal
Nicola Mastronardi, Executive Chef

WHAT ARE FIVE HOME PANTRY STAPLES?
Extra virgin olive oil, Italian spices, 30-year-old
Balsamic vinegar, pasta and wine

WHAT IS YOUR FAVORITE SONG/MUSICIAN TO UNWIND TO?
Adriano Celentano

IF YOU HAD 15 MINUTES TO PREPARE DINNER FOR GUESTS AT
YOUR HOME, WHAT WOULD YOU PREPARE?
Spaghetti with fresh tomatoes and basil or grilled meats

WHAT IS YOUR TYPICAL BREAKFAST?
Espresso

WHAT IS YOUR FAVORITE SNACK?
Caviar or small sandwiches of prosciutto

HOW DO YOU UNWIND AFTER A LONG STINT IN THE KITCHEN?
Watch television, read and play with my children

WHAT IS YOUR FAVORITE AROMA IN THE KITCHEN?
Basil

IF YOU ONLY HAD $10 TO PURCHASE INGREDIENTS FOR DINNER
FOR TWO, WHAT WOULD YOU MAKE?
Salad of mixed baby greens and pasta with fresh clams

WHAT IS YOUR STANDARD COMFORT FOOD?
Pasta

WHAT IS YOUR LEAST-FAVORED VEGETABLE?
Pumpkin

Word to the Wise:

When making soups, always

use bottled water—never tap water.

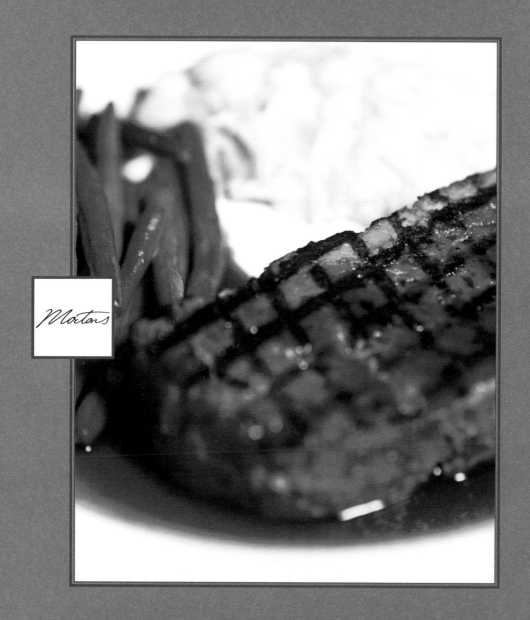

Morton's Turkey Meatloaf

5 lb ground white turkey meat

2 carrots, diced

1 white onion, diced

5 celery stalks, diced

2 eggs

1 Tbs garlic, minced

1 Tbs parsley, chopped

1 Tbs Worcestershire sauce

1 tsp salt

1 tsp pepper

Pinch paprika

Pinch cayenne pepper

Pinch Herbs of Provence

1 1/2 cup bread crumbs

1 Preheat oven to 450°. Sauté the diced vegetables until tender. Let cool.

2 Mix the cooked vegetables with the turkey. Add the eggs, garlic, parsley, salt, pepper, paprika, cayenne pepper, Herbs of Provence and Worcestershire sauce. Add bread crumbs.

3 Form into a big loaf and place on a baking sheet. Bake at 450° for 45 minutes to 1 hour—until nice and brown. Drizzle with sauce.

We use a homemade sauce from veal bones but Lawry's Au Jus works well.

Getting Personal
Pamela Morton, Proprietor

WHAT ARE FIVE HOME PANTRY STAPLES?
> Pasta, canned Italian tomatoes, Parmesan cheese, olive oil
> and cereal

WHAT IS YOUR FAVORITE SONG/MUSICIAN TO UNWIND TO?
> Classical music or opera

IF YOU HAD 15 MINUTES TO PREPARE DINNER FOR GUESTS AT
YOUR HOME, WHAT WOULD YOU PREPARE?
> Tricolore salad and spaghetti with tomato, basil and olive oil

WHAT IS YOUR TYPICAL BREAKFAST?
> Coffee, two whites of hard-boiled eggs and a glass of water

WHAT IS YOUR FAVORITE SNACK?
> Celery with peanut butter

HOW DO YOU UNWIND AFTER A LONG STINT IN THE KITCHEN?
> I don't spend much time in the kitchen at home

WHAT IS YOUR FAVORITE AROMA IN THE KITCHEN?
> Chocolate chip cookies baking in the oven

IF YOU ONLY HAD $10 TO PURCHASE INGREDIENTS FOR DINNER
FOR TWO, WHAT WOULD YOU MAKE?
> Pasta with Italian tomatoes, Parmesan cheese and basil
> and a salad

WHAT IS YOUR STANDARD COMFORT FOOD?
> Grape Nuts with milk

WHAT IS YOUR LEAST-FAVORED VEGETABLE?
> Okra

Word to the Wise:

The best way to chop an onion without tears

is by running the knife under cold water before slicing.

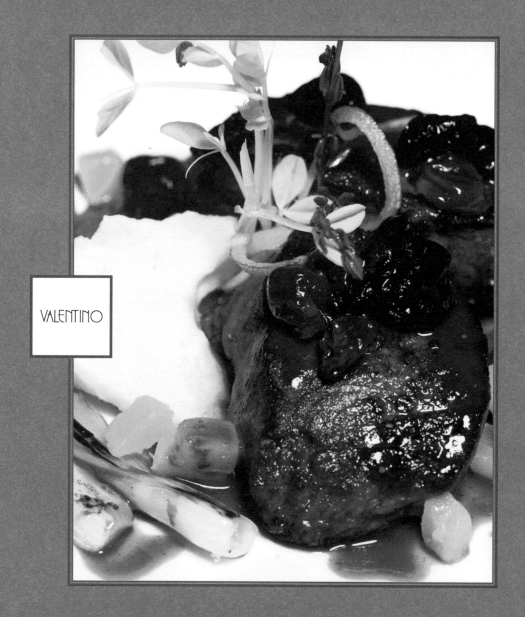

VALENTINO

Venison Fillet with Dark Cherries and Parmesan Mashed Potatoes

SERVES 4

2 fillets of venison tenderloin

1 Tbs thyme, finely chopped

1 Tbs sage, finely chopped

1 Tbs rosemary, finely chopped

1 shallot, finely chopped

4 garlic cloves, roughly chopped

1/2 bottle red wine
(Tignanello if possible)

1/2 cup dried dark cherries

3 Tbs olive oil

1 cup veal or beef stock

Salt and pepper

Parmesan mashed potatoes:

3 large Idaho potatoes,
peeled and diced

1 stick butter

1/2 cup cream

1/4 cup Parmesan cheese

Salt and pepper

1 Cut the fillets of venison into 2" medallion portions (8 pieces). Mix 1 clove of garlic, thyme, sage and rosemary. Rub the mixture over the meat and marinate for 1 hour.

2 Heat the olive oil in a pan and sauté the medallions to medium rare. Set aside.

3 In the same pan, add the remaining garlic, shallots and wine. Over medium heat, let the liquid evaporate to half the volume.

4 Strain the mixture. Add the cherries and stock. Reduce to half the volume until it is a sauce consistency.

5 Return the medallions to the sauce and serve over a bed of mashed potatoes.

6 To prepare the mashed potatoes: Boil the potatoes in salted water until done. Drain and mash the potatoes. Add the butter and, while stirring, slowly add the cream. Stir until fluffy. Add the Parmesan, salt and pepper to taste.

Getting Personal

Piero Salvaggio, Executive Chef/Proprietor

WHAT ARE FIVE HOME PANTRY STAPLES?
Oranges for fresh squeezed orange juice, ricotta cheese, olive pâté, garlic and tomato sauce

WHAT IS YOUR FAVORITE SONG/MUSICIAN TO UNWIND TO?
Madonna or Tommy Lipuma

IF YOU HAD 15 MINUTES TO PREPARE DINNER FOR GUESTS AT YOUR HOME, WHAT WOULD YOU PREPARE?
Caprese salad, frittata and any pasta

WHAT IS YOUR TYPICAL BREAKFAST?
Orange juice and later a cappuccino

WHAT IS YOUR FAVORITE SNACK?
Roasted salted peanuts

HOW DO YOU UNWIND AFTER A LONG STINT IN THE KITCHEN?
Swimming

WHAT IS YOUR FAVORITE AROMA IN THE KITCHEN?
Rosemary

IF YOU ONLY HAD $10 TO PURCHASE INGREDIENTS FOR DINNER FOR TWO, WHAT WOULD YOU MAKE?
Pasta, salad and a wedge of cheese

WHAT IS YOUR STANDARD COMFORT FOOD?
Bread and cold cuts, especially prosciutto

WHAT IS YOUR LEAST-FAVORED VEGETABLE?
Summer squash

Word
to the
Wise:

Always peel garlic at the very last moment so that

the flavor is intact. Discard garlic

from cooking after it has been used to add flavor.

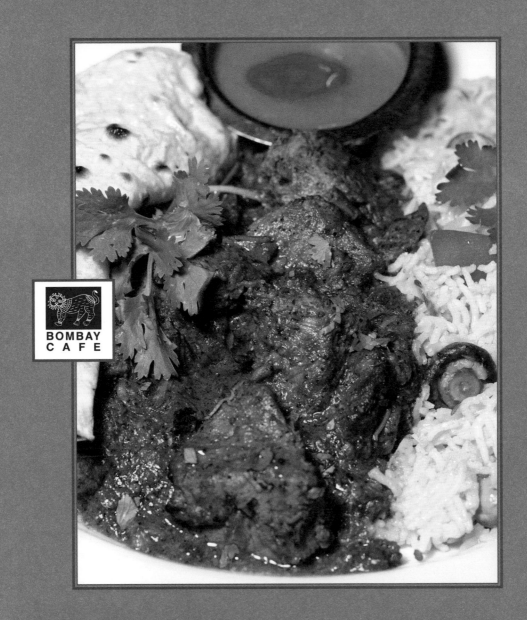

Lamb Vindaloo

SERVES 6

1/3 cup oil or ghee

1/2 tsp fenugreek seeds

2 medium onions, sliced thin

6–8 cloves garlic, sliced thin

2" piece peeled ginger, sliced thin

2 lb leg of lamb meat, cut into 2" cubes

4–5 serrano green chilies, sliced thin

1 tsp cayenne pepper

1/4 tsp turmeric

1 1/2 tsp salt

2 Tbs coriander seeds

1 tsp cumin seeds

1/2 tsp mustard seeds

4–6 cloves

3–4 black cardamoms

10–12 black peppercorns

1" piece cassia or cinnamon stick

1 tsp sugar

3 Tbs white vinegar

4 Tbs tamarind pulp, soaked and strained

Fresh cilantro leaves for garnish

1 Heat the oil or ghee in a 4–6 quart braiser on high heat. Add the fenugreek seeds. When they turn color slightly, add the onions, garlic and ginger. Sauté until the onions are golden brown and crisp.

2 Add the lamb and brown for 9–10 minutes, stirring frequently.

3 Add cayenne, turmeric and salt. Mix well and lower heat to simmer. Add 1/2 cup water. Cover and cook for 1 1/2 hours. (Check to see if lamb is drying out—if so, add a little water.)

4 Grind the coriander, cumin, mustard seeds, cloves, cassia, cardamom, peppercorns and sugar in spice grinder.

5 Add the spice mixture, vinegar and tamarind pulp to lamb. Cook for an additional 20 minutes—adding water if necessary. Garnish with cilantro and serve hot with rice or chapatis.

Getting Personal
Neela Paniz, Executive Chef

WHAT ARE FIVE HOME PANTRY STAPLES?
Dals (lentils), Basmati rice, atta (soft whole-wheat flour), besan (chickpea flour) and the whole spectrum of Indian spices

WHAT IS YOUR FAVORITE SONG/MUSICIAN TO UNWIND TO?
Nusrat Fatch Ali Khan while cooking

IF YOU HAD 15 MINUTES TO PREPARE DINNER FOR GUESTS AT YOUR HOME, WHAT WOULD YOU PREPARE?
Pasta with Indian spices

WHAT IS YOUR TYPICAL BREAKFAST?
Toast and Darjeeling tea

WHAT IS YOUR FAVORITE SNACK?
Dried fruit and nut mix

HOW DO YOU UNWIND AFTER A LONG STINT IN THE KITCHEN?
Watch a good movie on television

WHAT IS YOUR FAVORITE AROMA IN THE KITCHEN?
Frying onions and boiling milk

IF YOU ONLY HAD $10 TO PURCHASE INGREDIENTS FOR DINNER FOR TWO, WHAT WOULD YOU MAKE?
A typical Indian meal of rice, dal, gobi sabzi (cauliflower with ginger and chilies) raita (yogurt with cucumbers and roasted cumin), and ground lamb kebabs

WHAT IS YOUR STANDARD COMFORT FOOD?
Rice and dal

WHAT IS YOUR LEAST-FAVORED VEGETABLE?
Pumpkin

Word
to the
Wise:

Soak basmati rice for a minimum of 20 minutes

prior to cooking — it enhances the grain

length and allows for more flavor to emerge.

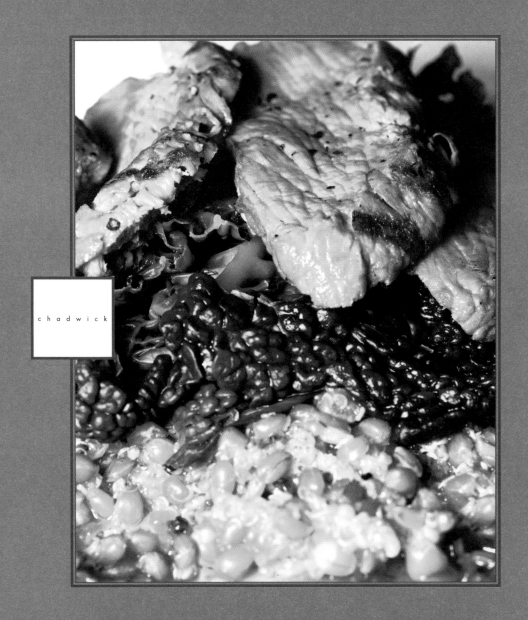

chadwick

Pork Tenderloin with Quinoa and Tuscan Cabbage

SERVES 6

2 pork tenderloins,
 cleaned and de-fatted

6 Tbs garlic, sliced

6 pinches pickled parsley leaves

3 cups cooked wheat berries

3 cups cooked quinoa

6 oz chicken stock

4 fluid oz shallot confit

4 cups Tuscan cabbage

1 Tbs chopped fresh thyme

1/2 cup olive oil

Kosher salt and pepper

1 Marinate the pork loin with olive oil and fresh thyme for 6 hours.

2 Pre-cook the quinoa and wheat berries to product specifications.

3 Blanch the Tuscan cabbage in boiling salted water until tender, then chill in ice water to preserve the color and texture. Confit the finely diced shallots in olive oil in a pan by covering the shallots with oil and allowing them to caramelize slowly. Let cool to room temperature and add the finely chopped thyme.

4 Grill the pork loin to desired temperature, season with salt and pepper and let rest. Add the quinoa and continue to cook for another minute. Finish with the chicken stock and salt.

5 Prepare the plate by mounding the grains in the middle of the plate. Create a well in the center to hold the Tuscan cabbage. Slice the pork loin and arrange over the cabbage. Finish the dish with shallot confit and serve.

Getting Personal

Ben Ford, Chef/Proprietor

WHAT ARE FIVE HOME PANTRY STAPLES?
High-quality olive oil, Kosher salt, organic unbleached flour,
late-harvest Riesling vinegar and a good bottle of Chardonnay

WHAT IS YOUR FAVORITE SONG/MUSICIAN TO UNWIND TO?
Eddie Hazel

IF YOU HAD 15 MINUTES TO PREPARE DINNER FOR GUESTS AT
YOUR HOME, WHAT WOULD YOU PREPARE?
Salad Niçoise

WHAT IS YOUR TYPICAL BREAKFAST?
Peet's coffee

WHAT IS YOUR FAVORITE SNACK?
Peet's coffee

HOW DO YOU UNWIND AFTER A LONG STINT IN THE KITCHEN?
Dinner in *someone else's* restaurant

WHAT IS YOUR FAVORITE AROMA IN THE KITCHEN?
Our oakwood fire in Chadwick's kitchen

IF YOU ONLY HAD $10 TO PURCHASE INGREDIENTS FOR DINNER
FOR TWO, WHAT WOULD YOU MAKE?
Grilled vegetable risotto

WHAT IS YOUR STANDARD COMFORT FOOD?
Matzo ball soup with a cream soda

WHAT IS YOUR LEAST-FAVORED VEGETABLE?
Green bell peppers

Word to the Wise:

The easy way to clean a pomegranate is

to submerge the fruit and your hands in cold water.

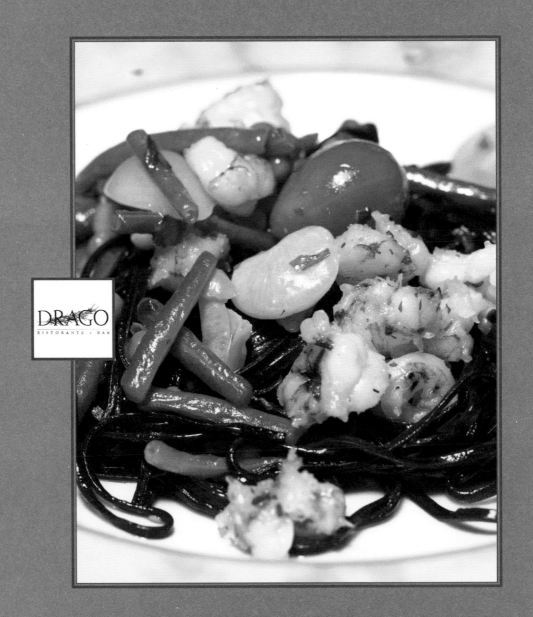

Squid Ink Tagliolini with Rock Shrimp

SERVES 4

1 lb squid ink tagliolini

20 rock shrimp, cleaned (chop 8 into small pieces and leave 12 whole)

1/2 cup fava beans, boiled al dente

1/2 cup haricots-verts, boiled al dente

1/2 cup peas, boiled al dente

20 cherry tomatoes, halved

1 small shallot, chopped

2 garlic cloves, chopped

6 Tbs olive oil

1 Tbs butter

1 small glass brandy

1 small glass dry white wine

1/2 cup fish or vegetable stock

Salt and pepper

1 Sauté the shallot and garlic in a pan with 4 Tbs of olive oil. Add all the rock shrimp and sauté until they are golden brown.

2 Add the white wine and allow it to evaporate. Repeat process with the brandy.

3 Bring a pot of salted water to a boil.

4 Add the fava beans, haricots-verts, peas and cherry tomatoes to the sauté pan. Let simmer for 4–6 minutes. Add 1/2 cup of the fish or vegetable stock and allow to cook for 4–6 minutes. Season with salt and pepper to taste.

5 Remove the 12 whole rock shrimp and set aside.

6 Place the squid ink pasta in the boiling water and follow cooking time on package.

7 Drain the pasta when it is al dente and add it to the sauce in the sauté pan. While tossing the pasta in the pan, add the butter and 2 Tbs of olive oil. Add more of the stock if it seems too dry.

8 To serve, place the pasta on 4 plates and top each dish with 3 whole shrimp.

Getting Personal
Celestino Drago, Executive Chef

WHAT ARE FIVE HOME PANTRY STAPLES?
Olive oil, balsamic vinegar, salt, pepper and mustard

WHAT IS YOUR FAVORITE SONG/MUSICIAN TO UNWIND TO?
Frank Sinatra's "New York, New York"

IF YOU HAD 15 MINUTES TO PREPARE DINNER FOR GUESTS AT YOUR HOME, WHAT WOULD YOU PREPARE?
Spaghetti with tomato sauce

WHAT IS YOUR TYPICAL BREAKFAST?
Sandwiches and orange juice

WHAT IS YOUR FAVORITE SNACK?
Doughnuts and pastries

HOW DO YOU UNWIND AFTER A LONG STINT IN THE KITCHEN?
Have a glass of wine

WHAT IS YOUR FAVORITE AROMA IN THE KITCHEN?
Rosemary

IF YOU ONLY HAD $10 TO PURCHASE INGREDIENTS FOR DINNER FOR TWO, WHAT WOULD YOU MAKE?
Salad with chicken and mustard dressing

WHAT IS YOUR STANDARD COMFORT FOOD?
Pasta

WHAT IS YOUR LEAST-FAVORED VEGETABLE?
Broccoli

Word
to the
Wise:

The best way to get a nicely flavored béchamel sauce

is to add to the milk a whole onion

that has been pickled with cloves.

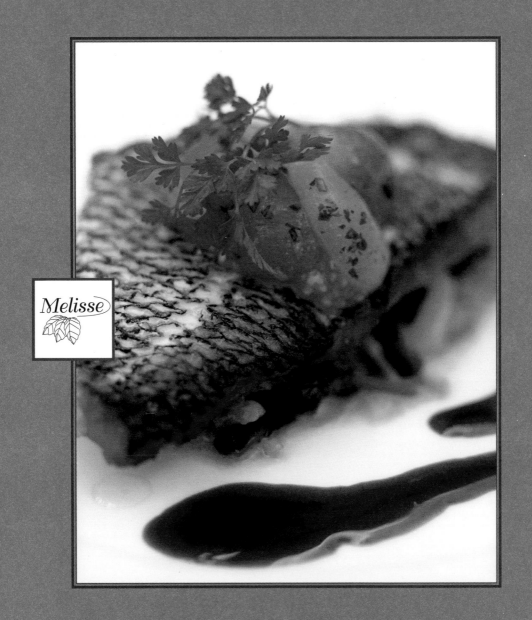

Sautéed Black Bass with Tomato Braised Fennel and Red Wine Sauce

SERVES 6

6 black bass fillets, 6 oz
 each, boned and skin on
2 fennel bulbs
1/2 sweet onion, sliced
2 cups baby spinach,
 packed tightly
10 beefsteak tomatoes

1 tsp salt
1 cup Napa cabbage, sliced
1/4 cup extra virgin olive oil
2 Tbs butter
Fleur de sel for garnish

Red wine sauce:
1 1/2 cup red wine
1 cup port wine
1/4 cup carrot puree
1 Tbs butter
Salt and pepper
Oil for cooking

1 Prepare the tomato essence the day before: Blend the tomatoes and salt in a food processor. Tie the tomato puree in cheesecloth and allow it to drain out into a container. Store the liquid in the refrigerator.

2 Core the fennel bulbs and slice into half circles, 1/4" thick. Heat a large skillet over medium heat. Add 1 tsp oil and 1 Tbs butter and melt. Add onions and cook 3–4 minutes, stirring occasionally. Add the fennel and season with salt and pepper. Add the tomato liquid and bring to boil. Reduce to a simmer and add the cabbage. Let cook 8–12 minutes until fennel is tender, not mushy. Set aside.

3 Reduce both wines until 1/2 cup remains. Whisk in the carrot puree and boil for 3 minutes. Whisk in 1 Tbs butter. Season with salt and pepper to taste. Strain the sauce through a fine strainer. Keep warm.

4 Heat a large nonstick skillet on high heat. Season the bass with salt and a little pepper. Add oil to the pans to 1/8". Place the fish in the pan, skin-side down. Press down with a spatula. Reduce heat and sauté for 3–4 minutes. Remove from heat and turn the fish over. Let sit for 1 minute. Remove from pan.

5 While the fish is cooking, reheat the fennel. Add the baby spinach and mix until it wilts. Add 1 Tbs of butter and mix in. Heat 6 dinner plates and place a bed of sauce in the center of each. Top with a mound of fennel and cabbage mixture. Place fish skin-side up and sprinkle skin with fleur de sel.

Getting Personal
Josiah Citrin, Executive Chef

WHAT ARE FIVE HOME PANTRY STAPLES?
Extra virgin olive oil, soy sauce, balsamic vinegar, salt and pepper

WHAT IS YOUR FAVORITE SONG/MUSICIAN TO UNWIND TO?
John Coltrane's "My Favorite Things"

IF YOU HAD 15 MINUTES TO PREPARE DINNER FOR GUESTS AT YOUR HOME, WHAT WOULD YOU PREPARE?
Grilled Salmon, asparagus and a lemon-tomato vinaigrette

WHAT IS YOUR TYPICAL BREAKFAST?
Triple espresso and toast

WHAT IS YOUR FAVORITE SNACK?
Ham and Swiss cheese on a baguette (in a Paris café)

HOW DO YOU UNWIND AFTER A LONG STINT IN THE KITCHEN?
Go home and spend time with my kids

WHAT IS YOUR FAVORITE AROMA IN THE KITCHEN?
Truffles

IF YOU ONLY HAD $10 TO PURCHASE INGREDIENTS FOR DINNER FOR TWO, WHAT WOULD YOU MAKE?
Rigatoni pasta

WHAT IS YOUR STANDARD COMFORT FOOD?
Italian subs

WHAT IS YOUR LEAST-FAVORED VEGETABLE?
Okra

Word to the Wise:

Always season with high-quality salt and pepper.

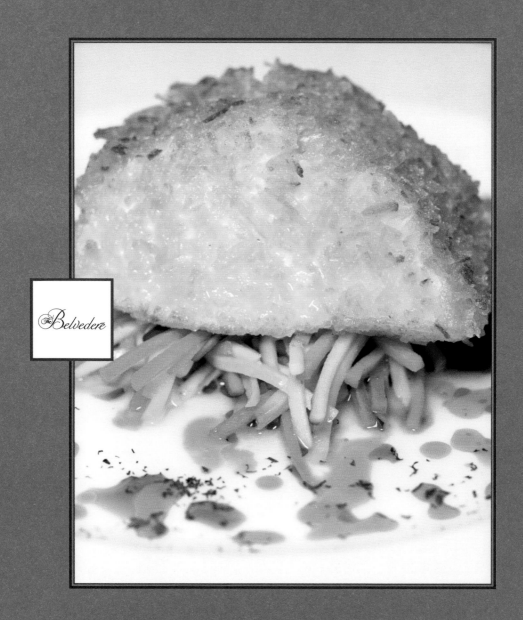

Potato-Crusted Chilean Sea bass with Fresh Dill and Orange Reduction

SERVES 4

4 fillets of sea bass, 6 oz
each, cleaned and boned

5 medium Idaho potatoes

2 eggs, beaten

3 Tbs flour

1 medium zucchini

1 medium yellow squash

1/2 medium carrot

1 1/2 Tbs fresh dill
(reserve 8 sprigs)

1/4 cup salad oil

1 1/4 cup orange juice

8 orange segments

Salt, white pepper, flour

1 To prepare the potato crust: Peel potatoes and cut into a fine julienne. Soak in a large pot of cold water for several hours to remove the starch. Drain well. Heat a deep fryer to 375° and fry the potato slices until crispy—not brown. Let sit for 1 hour to drain excess fat. Crush the potato into very fine crumbs with your hands.

2 To prepare the dill oil: Plunge dill in boiling water and remove quickly. Heat the salad oil in a saucepan to 175° and pour over the blanched dill. Place in a blender for 30 seconds. Reserve the mixture for 24 hours at room temperature. Strain the mixture and refrigerate the remaining oil. It should be dark green in color. Oil and crust can be prepared a day ahead.

3 To prepare the orange reduction: Place orange juice in a small pot and simmer very slowly. Strain the foam to prevent a bitter taste. If it seems bitter, add a small amount of sugar. Reduce to approximately 4 oz.

4 Clean and cut the vegetables into matchstick-size pieces. Use only the outside of the squash and zucchini for the color. Finely chop 4 dill sprigs.

5 Preheat a sauté pan over medium heat and add 3 Tbs of olive oil. Season the fish with salt and pepper and lightly coat with flour. Dip the fish into the eggs and coat well with the potato crumbs. Place in the pan and brown well on both sides. Place on a rack and finish cooking in the oven at 425° until cooked throughout (about 10 minutes depending on thickness).

6 Blanch the vegetables in boiling water. Drain and toss with butter, salt and pepper.

7 Drizzle 1/2 oz of dill oil and then orange reduction on the base of 4 plates. Sprinkle chopped dill. Divide the vegetables into the center of the plates and place the fish on top. Garnish with 2 orange segments and dill sprigs.

Getting Personal

Bill Bracken, Executive Chef

WHAT ARE FIVE HOME PANTRY STAPLES?
Oreos, olive oil, porcini powder, Johnny's seasoning, Doritos chips

WHAT IS YOUR FAVORITE SONG/MUSICIAN TO UNWIND TO?
Paul Simon

IF YOU HAD 15 MINUTES TO PREPARE DINNER FOR GUESTS AT
YOUR HOME, WHAT WOULD YOU PREPARE?
Prime New York steaks with heirloom tomato and feta salad

WHAT IS YOUR TYPICAL BREAKFAST?
Raisin Bran and a Gala apple

WHAT IS YOUR FAVORITE SNACK?
Coca-Cola

HOW DO YOU UNWIND AFTER A LONG STINT IN THE KITCHEN?
My long drive home

WHAT IS YOUR FAVORITE AROMA IN THE KITCHEN?
Any fresh herb, especially rosemary

IF YOU ONLY HAD $10 TO PURCHASE INGREDIENTS FOR DINNER
FOR TWO, WHAT WOULD YOU MAKE?
Pan-roasted, prosciutto-wrapped chicken thighs with
Yukon potatoes, braised leeks and corn

WHAT IS YOUR STANDARD COMFORT FOOD?
Mashed potatoes

WHAT IS YOUR LEAST-FAVORED VEGETABLE?
Cauliflower or lima beans

Word to the Wise:

Most herbs can be sliced or diced instead of chopped —

to prevent them from turning black.

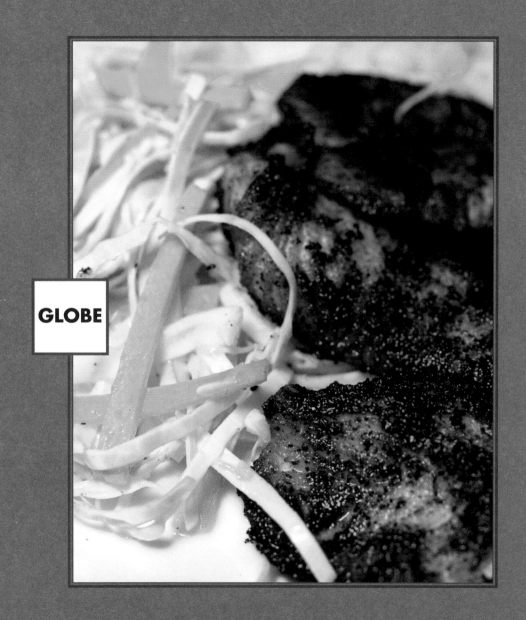

GLOBE

Blackened Chilean Sea bass with Lemony Coleslaw

SERVES 4

4 Chilean sea bass,
 7 oz each, cut
 lengthwise 1/4" thin

1 lb butter

Salt and pepper

Blackened Seasoning:

1/2 cup paprika

1/4 cup cayenne powder

1/4 cup garlic powder

2 Tbs white pepper

1/4 cup cumin powder

2 Tbs chili powder

1/4 cup onion powder

2 dried guahillo peppers,
 toasted and finely ground

Lemony Coleslaw:

2 cups Napa cabbage,
 julienned

1/2 cup red cabbage,
 julienned

1/4 cup carrots, julienned

1 cup mayonnaise

1/4 cup fresh-squeezed
 lemon juice

1 Tbs dry English mustard

1/2 tsp paprika

Pinch cayenne pepper

Salt and pepper to taste

3 Tbs granulated sugar

1. To prepare the seasoning: In a bowl mix all the spices evenly. Place spice mixture on a sheet pan and cover tightly with aluminum foil. Bake at 350° for 15 minutes to allow the bitterness to cook out. Remove the foil and bake for an additional 10 minutes uncovered.

2. To prepare coleslaw: Julienne the Napa cabbage, red cabbage and carrots. In a mixer with a wire whip attachment, mix the mayonnaise, lemon juice, mustard, paprika, cayenne pepper, salt, pepper and sugar. Toss the julienned vegetables with the mayonnaise mixture.

3. In a double boiler, melt the butter over low heat. Allow the butter to clarify.

4. Season the sea bass with salt and pepper. Coat both sides with blackened seasoning and then coat lightly with clarified butter.

5. Heat a cast-iron skillet to 400°. Gently add the sea bass as fish cooks quickly. Flip when desired blackening occurs.

6. Serve Chilean sea bass on a bed of lemony coleslaw.

Getting Personal
Robert Roaquin, Executive Chef

WHAT ARE FIVE HOME PANTRY STAPLES?
Balsamic vinegar, mayonnaise, Dijon mustard, extra virgin olive oil and Grana Padano cheese

WHAT IS YOUR FAVORITE SONG/MUSICIAN TO UNWIND TO?
None—cooking makes its own music

IF YOU HAD 15 MINUTES TO PREPARE DINNER FOR GUESTS AT YOUR HOME, WHAT WOULD YOU PREPARE?
Chicken cutlet Parmesan, linguini with garlic and oil and a small salad

WHAT IS YOUR TYPICAL BREAKFAST?
Any kind of bread toasted…if I feel healthy, oatmeal with raisins

WHAT IS YOUR FAVORITE SNACK?
Oreos, Ruffles potato chips and Häagen-Dazs Macadamia Brittle

HOW DO YOU UNWIND AFTER A LONG STINT IN THE KITCHEN?
Watch ESPN…see if any of my picks win

WHAT IS YOUR FAVORITE AROMA IN THE KITCHEN?
Burned or charred shrimp shells

IF YOU ONLY HAD $10 TO PURCHASE INGREDIENTS FOR DINNER FOR TWO, WHAT WOULD YOU MAKE?
I would go to a nice Italian deli and buy a baguette, a couple of thin slices of prosciutto and fresh buffalo mozzarella

WHAT IS YOUR STANDARD COMFORT FOOD?
Grilled prime cut steaks, rustic-style pastas, risotto and mashed potatoes

WHAT IS YOUR LEAST-FAVORED VEGETABLE?
I like all the vegetables earth provides

Word to the Wise:

Do not rinse cooked pasta under cold water

or you will wash off all the gluten

and lose the body and flavor.

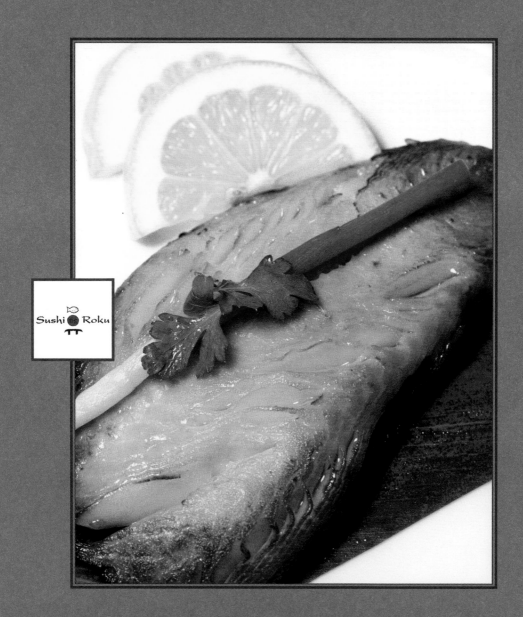

Baked Cod Marinated in Miso

SERVES 4

1/2 cup Saikyo sweet miso paste

1 cup Shiro white miso paste

1/4 cup Hancho miso paste

1/2 cup sugar

1/4 cup sake (Japanese rice wine)

1/4 cup Mirin (sweet cooking sake)

1 lb cod fillet,
 boned and cut into 4 pieces

1 Mix all the ingredients in a mixing bowl and stir evenly until it is a silky consistency. Place the cod fillet in the marinade and refrigerate 3–4 hours minimum.

2 Preheat oven to 375°. Place cod in the oven and bake for 10–12 minutes. Do not turn over.

Getting Personal
Michael Hide Cardenas, Owner/General Manager

WHAT ARE FIVE HOME PANTRY STAPLES?
Rice, pasta, miso paste, canned tomatoes, flour and konbu (dried kelp)

WHAT IS YOUR FAVORITE SONG/MUSICIAN TO UNWIND TO?
No particular musician or song but classical tunes for Italian cooking gets me going

IF YOU HAD 15 MINUTES TO PREPARE DINNER FOR GUESTS AT YOUR HOME, WHAT WOULD YOU PREPARE?
Fried rice (with corn, ham or bacon, egg, onion, takana (Japanese pickled mustard chard), garlic, soy sauce and a touch of sesame oil), a side of miso soup with wakame kelp and a green salad with ginger soy dressing

WHAT IS YOUR TYPICAL BREAKFAST?
Just coffee, toasted bread with jam and a piece of fresh fruit in season or a power bar and Red Bull (energy drink)

WHAT IS YOUR FAVORITE SNACK?
Power bar and Red Bull or a Jamba Juice or seasonal fresh fruit

HOW DO YOU UNWIND AFTER A LONG STINT IN THE KITCHEN?
Kick back, have a beer and dream

WHAT IS YOUR FAVORITE AROMA IN THE KITCHEN?
Garlic, garlic, garlic, garlic and more garlic

IF YOU ONLY HAD $10 TO PURCHASE INGREDIENTS FOR DINNER FOR TWO, WHAT WOULD YOU MAKE?
Whole roasted garlic chicken stuffed with potatoes and carrots, tortillas and cream of corn soup

WHAT IS YOUR STANDARD COMFORT FOOD?
Miso soup, Japanese pickles, rice and a piece of grilled salmon or mackerel with grated daikon

WHAT IS YOUR LEAST-FAVORED VEGETABLE?
Brussels sprouts or other bitter veggies

Word to the Wise:

Go to your local farmers market... Not only are there

interesting ingredients, but the farmers can offer

tips about favorite cooking techniques. Most importantly,

use fresh ingredients at all times and try to enjoy

the purity of each item—the less cooking the better.

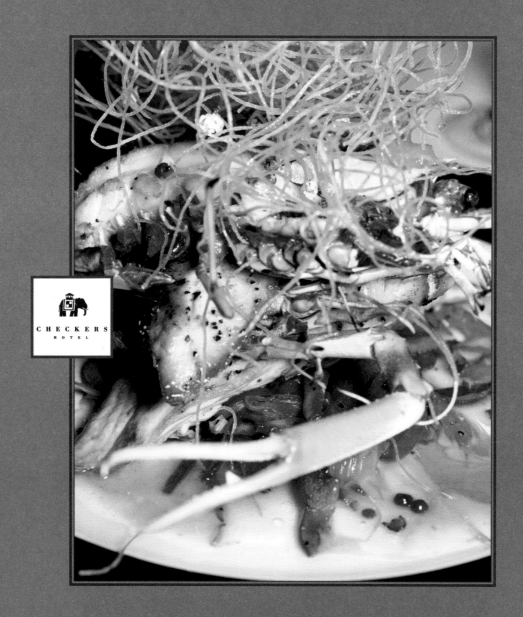

Tower of Mahi Mahi
and Grilled New Zealand Scampi

SERVES 1

8 oz mahi mahi
2 New Zealand scampi, sliced in half
1/4 cup fried sweet potato, julienned
1/4 cup celery
1/4 cup carrots
1/4 cup snow peas
1/4 cup peppers
1 oz clarified butter
1 oz butter
Sesame oil

Rice vinegar
Salt and pepper to taste
Baby's breath flowers for garnish

Pink peppercorn sauce:
1 Tbs pink peppercorns
1 Tbs diced pineapple
1 tsp clarified butter
3 tsp shallots
1 Tbs honey
4 Tbs champagne
3 oz butter

1 Preheat oven to 450°. Place clarified butter in a pan and reheat. Season the mahi mahi with salt and pepper. Add the mahi mahi to the pan and bring to a golden brown on both sides. Place in oven and bake for 3–4 minutes.

2 Heat another pan and add clarified butter. Place scampi in pan and cook to a golden brown. Place the scampi on a heated grill for 2–3 minutes.

3 Stir-fry the celery, carrots, snow peas and peppers in sauté pan with sesame oil, rice vinegar, salt and pepper for 3–4 minutes. Season to taste.

4 To prepare sauce: In a heated pan, place 1 tsp clarified butter. Add shallots, pineapple and pink peppercorns. Sauté for 2–3 minutes. Add honey and bring to a bubbling consistency. Add champagne, reduce to half the volume and add the butter.

5 To serve, place the stir-fried vegetables in the center of a 12" plate. Alternate layers of mahi mahi and scampi. Place a stack of fried sweet potato on top. Garnish with baby's breath flowers.

Getting Personal
Tony Hodges, Executive Chef

WHAT ARE FIVE HOME PANTRY STAPLES?
Basmati rice, extra sharp cheddar cheese, tortillas, English tea and dark chocolate

WHAT IS YOUR FAVORITE SONG/MUSICIAN TO UNWIND TO?
I love Mozart because he is creative and inspirational

IF YOU HAD 15 MINUTES TO PREPARE DINNER FOR GUESTS AT YOUR HOME, WHAT WOULD YOU PREPARE?
Grilled salmon with baby field greens served with a warm pink peppercorn, champagne and maple syrup dressing

WHAT IS YOUR TYPICAL BREAKFAST?
Twinings English breakfast tea with milk and sugar

WHAT IS YOUR FAVORITE SNACK?
A toasted bagel covered with fresh jalapeños and cheddar cheese

HOW DO YOU UNWIND AFTER A LONG STINT IN THE KITCHEN?
Check the stock market

WHAT IS YOUR FAVORITE AROMA IN THE KITCHEN?
The smell of freshly made granola being toasted

IF YOU ONLY HAD $10 TO PURCHASE INGREDIENTS FOR DINNER FOR TWO, WHAT WOULD YOU MAKE?
Salmon baked in phyllo dough

WHAT IS YOUR STANDARD COMFORT FOOD?
Spicy beef curry

WHAT IS YOUR LEAST-FAVORED VEGETABLE?
Okra

Word to the Wise:

To keep cooked pasta from sticking together,

drain the cooking water and toss with a dash of oil.

It is perfect to serve immediately or refrigerate for later.

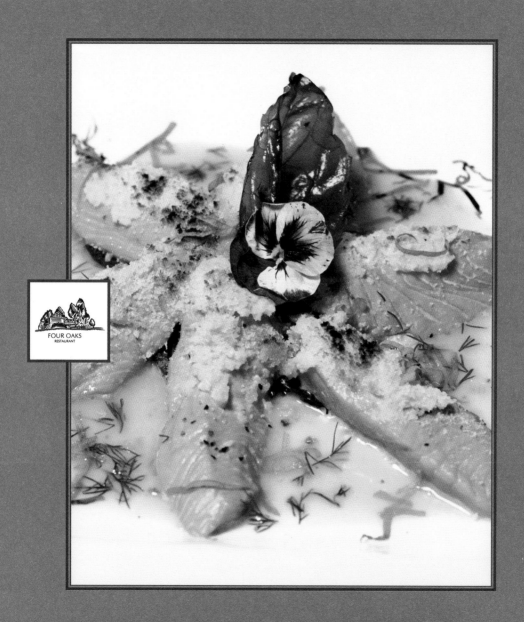

Horseradish Crusted Salmon
with Orange Vodka Broth

SERVES 4

4 salmon fillets, 5 oz each

1 Tbs horseradish, grated

1 Tbs butter, melted

1 cup fresh bread crumbs

2 oranges, juiced

1 lemon, juiced

1 Tbs orange rind

1 Tbs lemon rind

1 oz vodka

2 Tbs cold butter

Salt and pepper

1 Tbs dill, chopped

1 Tbs salmon caviar

1 Tbs shallots, chopped

1 Preheat oven to 400°. Combine the horseradish, melted butter, bread crumbs, salt and pepper to taste in a small bowl. Place the salmon fillets on a lightly buttered baking sheet. Cover each fillet with the bread crumb mixture. Bake in the oven for 5 minutes.

2 In a medium-size saucepan, mix the orange and lemon juices, vodka, orange and lemon rinds and shallots. Bring to a boil. Whisk in the cold butter, salt and pepper to taste. Remove from heat and add fresh dill and salmon caviar.

3 Place the salmon on a serving plate and surround with sauce. Serve immediately.

Getting Personal
Peter Roelant, Executive Chef

WHAT ARE FIVE HOME PANTRY STAPLES?
White truffle oil, aged Balsamic vinegar, nuts, home-dried herbs and dried fruits

WHAT IS YOUR FAVORITE SONG/MUSICIAN TO UNWIND TO?
Groovy jazz

IF YOU HAD 15 MINUTES TO PREPARE DINNER FOR GUESTS AT YOUR HOME, WHAT WOULD YOU PREPARE?
A barbecue in the garden

WHAT IS YOUR TYPICAL BREAKFAST?
Coffee, croissant and jam, the paper

WHAT IS YOUR FAVORITE SNACK?
Smoked salmon and caviar blinis

HOW DO YOU UNWIND AFTER A LONG STINT IN THE KITCHEN?
Walk with my dog

WHAT IS YOUR FAVORITE AROMA IN THE KITCHEN?
Truffles, poaching foie gras and brioche in the oven

IF YOU ONLY HAD $10 TO PURCHASE INGREDIENTS FOR DINNER FOR TWO, WHAT WOULD YOU MAKE?
A fun pasta—shrimp, curry, coconut milk, ginger and orange rinds

WHAT IS YOUR STANDARD COMFORT FOOD?
Soups, soups and more soups

WHAT IS YOUR LEAST-FAVORED VEGETABLE?
I love them all—thanks, Mother Nature

Word
to the
Wise:

Eat good food and you'll have a good life!

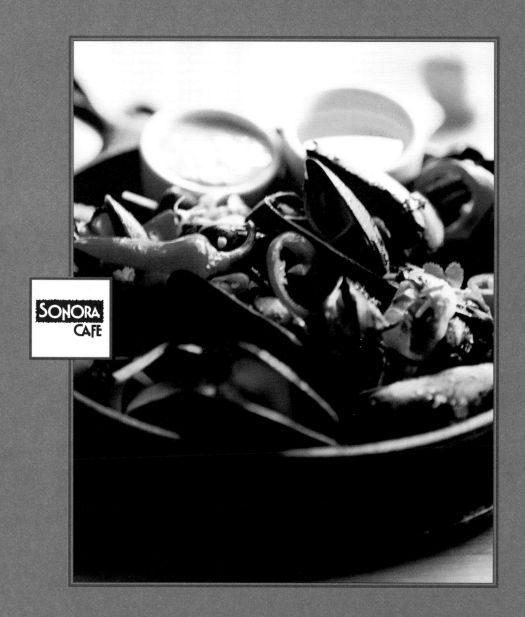

Rock Salt Baked Prince Edward Island Mussels with Cilantro-Jalapeño Mayonnaise

SERVES 6

6 lb Prince Edward Island Mussels

3 green Anaheim chilies, seeded and sliced into rings

3 red Anaheim chiles, seeded and sliced into rings

1/2 cup Kosher salt

1 bunch cilantro, leaves only

1 lb unsalted clarified butter for dipping

Cilantro-jalapeño mayonnaise:
(yields 2 1/2 cups)

2 garlic cloves, chopped

2 1/2 cups cilantro, leaves only

1 tsp sugar

1 tsp salt

1/2 tsp white pepper

1 tsp rice vinegar

2 egg yolks

1 Tbs fresh lime juice

1 jalapeño chile, seeded and chopped

1 cup extra virgin olive oil

3/4 cup walnut oil

1 Scrub each mussel thoroughly with a wire brush or plastic pot scrubber to remove the mud, grass and beard from the shell.

2 In a stainless steel bowl, toss the mussels with the chilies, salt and cilantro. Transfer to a cast-iron skillet and bake at 400° for 5 minutes or until the mussels open.

3 To prepare the mayonnaise: Place all ingredients except the oils in a blender. Begin blending and slowly add the oils in a steady stream. Blend until smooth.

4 Serve with the clarified butter and Cilantro-Jalapeño Mayonnaise.

Getting Personal
Felix Salcedo, Executive Chef

WHAT ARE FIVE HOME PANTRY STAPLES?
Flour, sugar, butter, salt and pepper

WHAT IS YOUR FAVORITE SONG/MUSICIAN TO UNWIND TO?
Julio Iglesias

IF YOU HAD 15 MINUTES TO PREPARE DINNER FOR GUESTS AT YOUR HOME, WHAT WOULD YOU PREPARE?
Fish tacos

WHAT IS YOUR TYPICAL BREAKFAST?
Eggs with tortillas

WHAT IS YOUR FAVORITE SNACK?
Popcorn

HOW DO YOU UNWIND AFTER A LONG STINT IN THE KITCHEN?
A glass of red wine

WHAT IS YOUR FAVORITE AROMA IN THE KITCHEN?
Garlic

IF YOU ONLY HAD $10 TO PURCHASE INGREDIENTS FOR DINNER FOR TWO, WHAT WOULD YOU MAKE?
Chicken fajitas

WHAT IS YOUR STANDARD COMFORT FOOD?
Tacos

WHAT IS YOUR LEAST-FAVORED VEGETABLE?
Okra

Word
to the
Wise:

An easy way to peel a chili: Roast on an open flame

for 5 minutes. Then place in a bowl with a little salt

and cover for about 3 minutes to steam—

the skin will come right off.

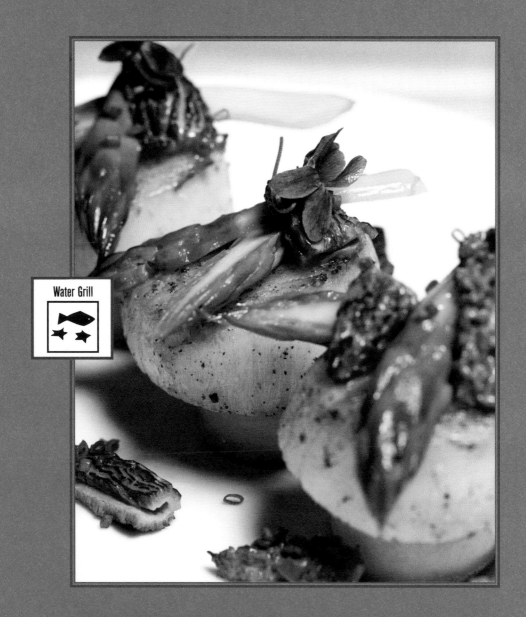

Water Grill

Maine Hand-Harvested Diver Scallops with Wild Mushrooms and Wild Greens

SERVES 4

8 diver scallops

1/2 cup mixed greens

1/4 cup mixed wild mushrooms, cleaned

1 Tbs Dijon mustard

2 Tbs sherry vinegar

5 Tbs extra virgin olive oil

8 tomatoes

Oil for sautéing

Salt and pepper to taste

1 To prepare the tomato confit: Peel and seed the tomatoes. Cut into quarters and lay them on a foiled sheet pan. Drizzle liberally with extra virgin olive oil, salt and pepper. Bake at 200° for 20 minutes—or until slightly dry.

2 Heat one sauté pan. Add 1 Tbs oil and mushrooms and sauté. Season with salt and pepper.

3 Place the mixed greens in a bowl along with the tomato confit.

4 In a jar, add the mustard, vinegar and extra virgin olive oil; place the lid on and shake vigorously to provide a well-emulsified vinaigrette. Place the mushrooms in the bowl with the greens and toss with the vinaigrette. Reserve a bit of the vinaigrette to dress the plate.

5 Heat a sauté pan. Add 1 Tbs oil. Season the scallops with salt and pepper and sauté in the preheated pan. When the scallops are cooked, remove them from the pan and place on a paper towel to drain the excess fat.

6 Begin plating by arranging the salad on warmed dinner plates. Place the scallops atop the salad; drizzle a bit of the vinaigrette on each plate. Serve immediately.

Getting Personal
Michael Cimarusti, Executive Chef

WHAT ARE FIVE HOME PANTRY STAPLES?
Sherry vinegar, great virgin olive oil, sardines, ramen noodles for
my daughter Isabella and mustard

WHAT IS YOUR FAVORITE SONG/MUSICIAN TO UNWIND TO?
"Natural Mystic" by Bob Marley and the Wailers

IF YOU HAD 15 MINUTES TO PREPARE DINNER FOR GUESTS AT
YOUR HOME, WHAT WOULD YOU PREPARE?
A nice salad with lots of fresh vegetables, hard-cooked or poached
eggs and bacon with a mustard vinaigrette

WHAT IS YOUR TYPICAL BREAKFAST?
Coffee!!!

WHAT IS YOUR FAVORITE SNACK?
Pistachios

HOW DO YOU UNWIND AFTER A LONG STINT IN THE KITCHEN?
Drive home slowly with the window down and the music up

WHAT IS YOUR FAVORITE AROMA IN THE KITCHEN?
Bacon and onions

IF YOU ONLY HAD $10 TO PURCHASE INGREDIENTS FOR DINNER
FOR TWO, WHAT WOULD YOU MAKE?
Herb roasted chicken with potatoes and onion cooked in the drippings
from the chicken in the same pan

WHAT IS YOUR STANDARD COMFORT FOOD?
Pasta

WHAT IS YOUR LEAST-FAVORED VEGETABLE?
Broccoli rabe

Word to the Wise:

When selecting a fish fillet at a market,

ask your grocer to see the whole fish, so as

to better judge the quality before you buy the fillet.

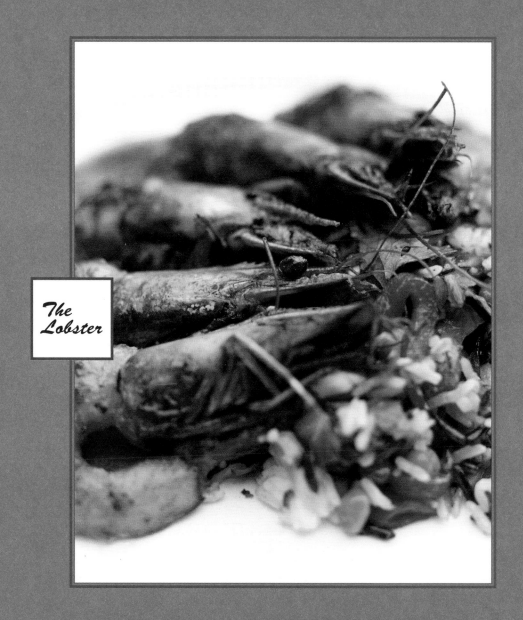

The Lobster

Spicy Louisiana Prawns with Vegetable Dirty Rice

SERVES 4

Vegetable dirty rice:

2 Tbs corn oil

1 cup cooked white rice

1 cup cooked wild rice

1/2 cup fresh green peas

1 red pepper, roasted and diced

1 cup cooked red beans

1 cup diced tomato

1/2 cup fresh corn kernels

1 cup raw spinach, julienned

1 tsp fresh oregano

1/2 tsp salt

1 Tbs fresh cilantro, chopped

1 tsp green Tabasco sauce

Freshly ground pepper

1 bunch cilantro for garnish

Louisiana prawns:

24 Louisiana prawns, heads on

3 Tbs corn oil

2 tsp garlic, chopped

1 Tbs Cajun spice mix

1/2 tsp salt

1/2 tsp black pepper, freshly ground

1 cup lobster or shrimp stock

4 Tbs unsalted butter

2 tsp Tabasco sauce

1 To prepare rice: Heat the oil in a sauté pan until very hot. Add the garlic and cook for about 10 seconds. Add the white rice, wild rice and vegetables and sauté until hot. Season with salt, pepper and oregano. Finish with green Tabasco sauce—to desired heat—and toss in chopped cilantro.

2 To prepare prawns: Heat the oil in a large sauté pan. Season the prawns with half of the Cajun spice and all of the salt. Add the garlic to the hot oil.

3 Add the prawns to the pan, laying flat on the pan bottom. Turn the prawns after 1 minute (and they are brown). Remove from the pan.

4 De-glaze the pan with lobster or shrimp stock. Add the remaining Cajun spice and reduce by half. Add Tabasco sauce to taste.

5 Reduce heat and add butter. Shake the pan until all the butter is melted.

6 Spoon warm rice in the center of the plate. Place 6 prawns around the rice and spoon the sauce over the prawns. Garnish with fresh sprigs of cilantro.

Getting Personal

Allyson Thurber, Executive Chef

WHAT ARE FIVE HOME PANTRY STAPLES?
Frank's RedHot Sauce, tortilla chips, cranberry juice, sun-dried tomato pesto and Kalamata olive puree

WHAT IS YOUR FAVORITE SONG/MUSICIAN TO UNWIND TO?
Luther Vandross

IF YOU HAD 15 MINUTES TO PREPARE DINNER FOR GUESTS AT YOUR HOME, WHAT WOULD YOU PREPARE?
Chicken tacos

WHAT IS YOUR TYPICAL BREAKFAST?
Coffee

WHAT IS YOUR FAVORITE SNACK?
McDonald's cheeseburger

HOW DO YOU UNWIND AFTER A LONG STINT IN THE KITCHEN?
A glass of wine and a tape of "All My Children"

WHAT IS YOUR FAVORITE AROMA IN THE KITCHEN?
Sautéed garlic and onions

IF YOU ONLY HAD $10 TO PURCHASE INGREDIENTS FOR DINNER FOR TWO, WHAT WOULD YOU MAKE?
Turkey meatloaf and a green salad

WHAT IS YOUR STANDARD COMFORT FOOD?
Macaroni and cheese

WHAT IS YOUR LEAST-FAVORED VEGETABLE?
Turnips or brussels sprouts

Word to the Wise:

When cooking shrimp,

always cook with the shell on —

that is where all the flavor is.

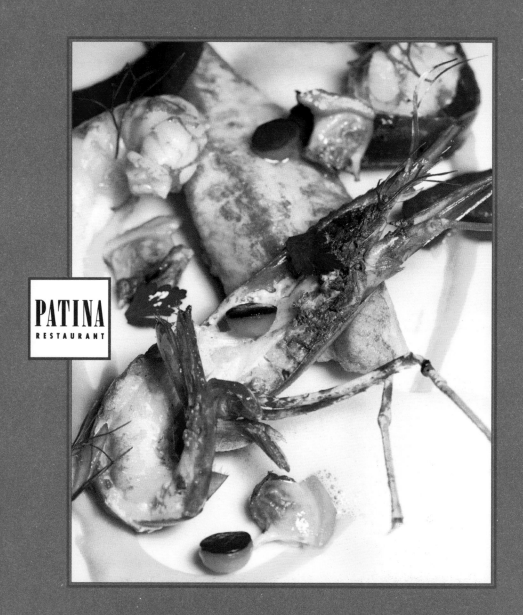

Sautéed John Dory Fillet with White Tarbais Bean Mousse and Warm Shellfish Vinaigrette

SERVES 4

White tarbais bean mousse:

1 cup white tarbais beans (or great northern beans), soaked overnight

1 garlic clove, crushed

1/4 white onion

1 sprig sage

1 sprig rosemary

1/4 cup extra virgin olive oil

Salt and pepper

Sherry wine vinegar

Tomato confit:

2 Roma tomatoes, peeled, seeded and quartered

Salt and pepper

Sugar

Olive oil

1 sprig thyme

Sliced garlic

20 balls of green zucchini (use a 1/2" melon ball scooper)

Shellfish nage:

3 Maine lobster tails in shell, cut into 8 segments

4 Santa Barbara shrimp with shell, halved

1/2 white onion, sliced

1 clove garlic, crushed

1 carrot, peeled and sliced

1 celery stalk, peeled and sliced

20 Manila clams

1/2 cup white wine

1 fresh bay leaf

1 sprig thyme

4 fillets John Dory

1 fresh bay leaf

1 Tbs butter, cold

1 lemon, juiced

Cold butter

Extra virgin olive oil, parsley leaves and fennel fronds for garnish

1 To prepare the mousse: Cook beans in water with garlic, onion, sage and rosemary until tender (approximately 3–4 hours). Blend into a fine puree with the olive oil. Season with salt, pepper and vinegar.

2 To prepare the confit: Preheat oven to 200°. Season the tomato with salt, pepper, a pinch of sugar and olive oil to coat. Place the tomatoes on a foil-lined baking sheet. Top each tomato with a small sprig of thyme and one slice of garlic. Bake for 20 minutes.

CONTINUED ON NEXT PAGE

Sautéed John Dory Fillet with White Tarbais Bean Mousse and Warm Shellfish Vinaigrette

3 Sauté the zucchini in a hot pan with olive oil. Do not brown.

4 To prepare the nage: In a deep pan, sauté the lobster and shelled shrimp in olive oil just until cooked. Do not brown. Add the onion, garlic, carrot and celery. Add water until everything is covered. Simmer for 30 minutes and strain. Reserve the liquid.

5 In a pot, cook the clams with the white wine, bay leaf and thyme. When the clams open, clean them and reserve the juice.

6 In a sauté pan, add the olive oil, 1 Tbs butter, bay leaf and John Dory.
Add salt and pepper.

7 Combine the nage liquid and clam juice in a pan and reduce to $1/2$ cup. Pour into a blender, then add lemon juice and butter. (Add enough butter so the consistency can coat the back of a spoon.) Blend until thick and frothy. Season with salt and freshly ground pepper.

8 Put the mousse on 4 plates. Arrange the seafood, zucchini and tomato confit on the plates. Garnish with the extra virgin olive oil, parsley leaves and fennel fronds. Drizzle the shellfish emulsion on the fish.

Getting Personal
Joachim Splichal, Executive Chef

WHAT ARE FIVE HOME PANTRY STAPLES?
French cheese, butter, pasta, strawberry marmalade, good five- or seven-grain whole wheat bread

WHAT IS YOUR FAVORITE SONG/MUSICIAN TO UNWIND TO?
The Cranberries

IF YOU HAD 15 MINUTES TO PREPARE DINNER FOR GUESTS AT YOUR HOME, WHAT WOULD YOU PREPARE?
Pasta with tomato and basil

WHAT IS YOUR TYPICAL BREAKFAST?
Coffee—black

WHAT IS YOUR FAVORITE SNACK?
Anything in Patina's kitchen

HOW DO YOU UNWIND AFTER A LONG STINT IN THE KITCHEN?
A good glass of red wine

WHAT IS YOUR FAVORITE AROMA IN THE KITCHEN?
Roasted vegetables

IF YOU ONLY HAD $10 TO PURCHASE INGREDIENTS FOR DINNER FOR TWO, WHAT WOULD YOU MAKE?
Roasted chicken breasts with lemon, thyme and carrots

WHAT IS YOUR STANDARD COMFORT FOOD?
Steak

WHAT IS YOUR LEAST-FAVORED VEGETABLE?
There are none

Word
to the
Wise:

Whenever you cook green vegetables,

cook them in very salty water and

upon removal from the water, shock

the vegetables in ice water to preserve the color.

Desserts

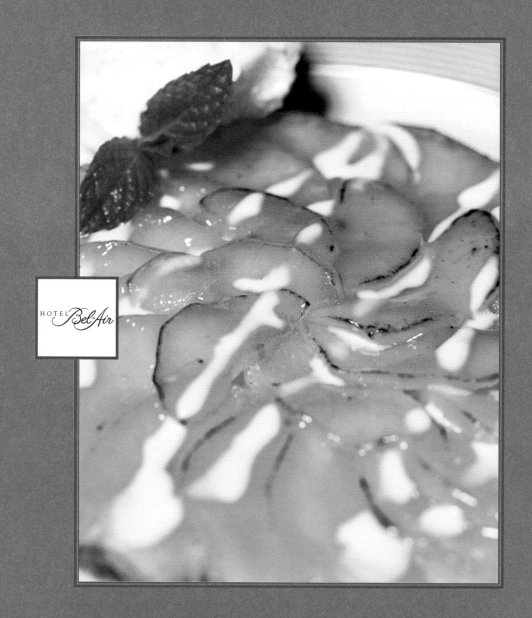

Crisp Pear Tart with Frangipane

SERVES 6

4–6 firm pears, peeled,
 cored and halved

1 cup water

1 cup white wine

1 cup sugar

1 vanilla bean

1 cinnamon stick

Puff pastry dough,
 homemade or
 store-bought

Frangipane:

8 oz almond paste

4 oz butter, softened

3 Tbs sugar

3 eggs

2 Tbs flour

Crème anglaise:

15 egg yolks

1 qt cream

1 1/4 cup vanilla essence,
 scraped from cut beans

3/4 cup sugar

1 Tbs apricot jam

1 Preheat oven to 350°. To prepare the frangipane: Beat the butter and sugar in a mixer until creamy. Mix in the almond paste and eggs until completely blended. Slowly add the flour and blend well. Refrigerate.

2 To prepare the crème anglaise: Bring the cream and vanilla essence to a boil. In a bowl, mix the egg yolks and sugar until smooth. Slowly stir half of the boiling cream into the egg mixture. Add this to the remaining cream in the saucepan. Over low heat, stir continuously until sauce thickens. Strain and cool.

3 In a separate pot, mix water, white wine, sugar, vanilla bean and cinnamon stick. Add the pears and bring to a boil. Poach the pears in the syrup mixture until tender but firm. Cool completely.

4 Roll the puff pastry to 1/8" thick and 6" wide. Place in 6" tart pan.

5 Spread frangipane thinly over the puff pastry. Using a fork, poke holes into dough. Slice the pears thinly and fan over the puff pastry. Sprinkle with sugar. Bake at 350° for about 20 minutes or until the bottom of the tart is brown.

6 Glaze lightly with apricot jam. Serve warm with crème anglaise drizzled over the tart and a scoop of vanilla ice cream.

Getting Personal
Robert Witkowski, Pastry Chef

WHAT ARE FIVE HOME PANTRY STAPLES?
Butter, sugar, chocolate, flour and spices

WHAT IS YOUR FAVORITE SONG/MUSICIAN TO UNWIND TO?
Riders in the Sky

IF YOU HAD 15 MINUTES TO PREPARE DINNER FOR GUESTS AT YOUR HOME, WHAT WOULD YOU PREPARE?
Pasta and cookies

WHAT IS YOUR TYPICAL BREAKFAST?
Tea, toast and honey

WHAT IS YOUR FAVORITE SNACK?
Apples

HOW DO YOU UNWIND AFTER A LONG STINT IN THE KITCHEN?
Play chess and read

WHAT IS YOUR FAVORITE AROMA IN THE KITCHEN?
Bacon

IF YOU ONLY HAD $10 TO PURCHASE INGREDIENTS FOR DINNER FOR TWO, WHAT WOULD YOU MAKE?
Soup and homemade bread

WHAT IS YOUR STANDARD COMFORT FOOD?
Chocolate

WHAT IS YOUR LEAST-FAVORED VEGETABLE?
Squash

Word to the Wise:

Always taste food with a spoon.

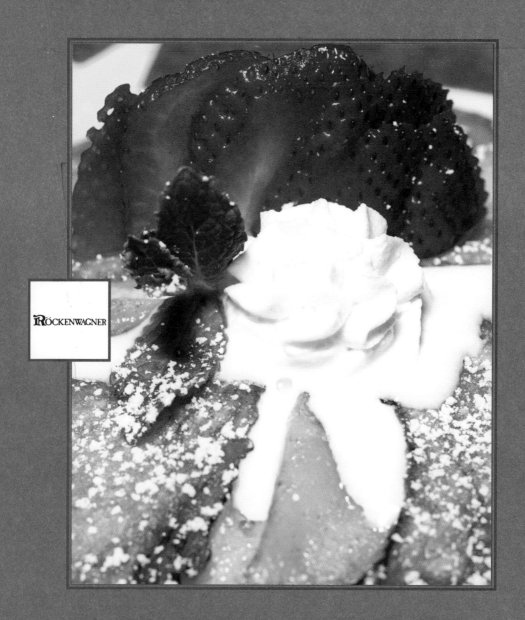

RÖCKENWAGNER

German Apple Pancake
with Crème Fraiche

Pancake batter:

7 large eggs

1 Tbs pure vanilla extract

3/4 cup granulated sugar

1/2 cup all-purpose flour

1 1/2 tsp baking powder

Apples:

2 Tbs unsalted butter

3 Golden Delicious apples, peeled, cored and cut into 1/2" wedges

1 1/2 tsp ground cinnamon

1 1/2 Tbs granulated sugar

1 Tbs confectioners' sugar

1/4 cup crème fraiche

1 cup strawberries for garnish

1 To prepare batter: In a blender or food processor, combine the eggs, vanilla and sugar. Blend for about 15 seconds or until combined. Add the flour and baking powder and mix for 60 seconds or until very smooth.

2 To prepare apples: Preheat the broiler to medium high heat. Heat a 12" nonstick skillet over medium heat and add the butter. Add the apples and sauté for 4–5 minutes or until softened. Add the cinnamon and sugar, sprinkling them evenly over the apples. Stir for 2 minutes or until the apples are glazed and slightly translucent at the edges.

3 Distribute the apples evenly in the skillet and pour the batter over them. Cook until the bottom seems quite firm, about 8 minutes. If you desire 4 pancakes, use a smaller pan and 1/4 of the apples and 1/4 of the batter for each pancake.

4 Transfer the pan to the broiler and, while watching carefully, cook until the pancake is firm throughout and golden on top.

5 Cut the pancake into 4 wedges and transfer them, apple-side up, to serving plates. Sprinkle with confectioners' sugar, place a dollop of crème fraiche on top and garnish with the strawberries.

Getting Personal

Hans Röckenwagner, Executive Chef

WHAT ARE FIVE HOME PANTRY STAPLES?
Cholula Hot Sauce, hot mustard, bread and butter pickles, Nutella chocolate-hazelnut spread and Dulche de Leche

WHAT IS YOUR FAVORITE SONG/MUSICIAN TO UNWIND TO?
Bee Gees—all of it

IF YOU HAD 15 MINUTES TO PREPARE DINNER FOR GUESTS AT YOUR HOME, WHAT WOULD YOU PREPARE?
Pasta with fresh tomato, basil and grilled shrimp

WHAT IS YOUR TYPICAL BREAKFAST?
Kellogg's corn flakes or Röckenwagner triberry scones

WHAT IS YOUR FAVORITE SNACK?
Rice Krispies

HOW DO YOU UNWIND AFTER A LONG STINT IN THE KITCHEN?
With a large glass of Heleweiss beer

WHAT IS YOUR FAVORITE AROMA IN THE KITCHEN?
Roasting lobster carcasses

IF YOU ONLY HAD $10 TO PURCHASE INGREDIENTS FOR DINNER FOR TWO, WHAT WOULD YOU MAKE?
Pasta with fresh tomato, basil and grilled shrimp

WHAT IS YOUR STANDARD COMFORT FOOD?
Spaetzle with anything

WHAT IS YOUR LEAST-FAVORED VEGETABLE?
Does not exist

Word
to the
Wise:

Often, sauces have a wonderful flavor but are somehow flat.

By adding vinegar and other acidic ingredients,

such as a citrus juice, depth is found.

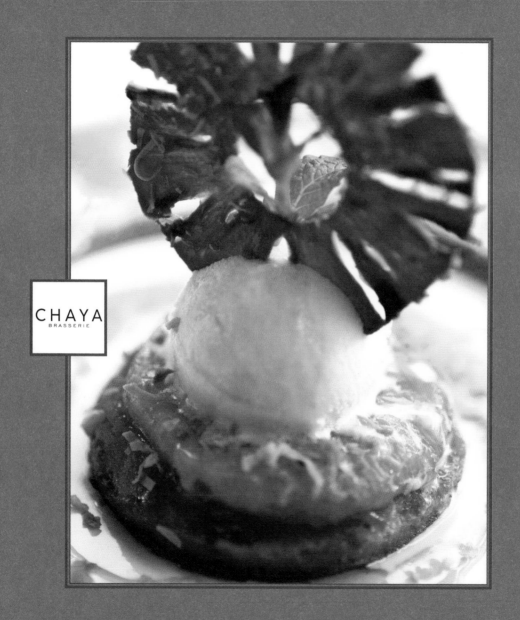

Individual Upside-Down Pineapple Cake

SERVES 3

1 1/4 cup butter

2/3 cup brown sugar

1/2 pineapple

3/4 cup sugar

2 eggs

1/2 Tbs vanilla extract

1 cup cake flour

1 Tbs baking powder

1 3/4 cup milk

Pineapple or coconut sorbet

Toasted coconut flakes to taste

Simple syrup:

1 cup sugar

1 cup water

1 Preheat oven to 300°. Core the pineapple and slice 1/2" thick. Poach the pineapple in simple syrup.

2 Melt 3/4 cup butter and add 2/3 cup brown sugar. Spread the mixture in the bottom of three 4" molds. Place the pineapple in the mold and set aside.

3 In a mixing bowl, cream 1/2 cup butter and 3/4 cup sugar. Beat in the eggs. Add the vanilla extract. Sift the flour and baking powder together. Add to the egg mixture—alternating with milk in two additions.

4 Pour the mixture into the prepared molds and bake for 15–20 minutes at 300°.

5 Serve with pineapple or coconut sorbet and garnish with toasted coconut flakes.

Getting Personal
Shigefumi Tachibe, Executive Chef

WHAT ARE FIVE HOME PANTRY STAPLES?
> Pasta, beans, onions, potatoes and carrots

WHAT IS YOUR FAVORITE SONG/MUSICIAN TO UNWIND TO?
> Reggae music

IF YOU HAD 15 MINUTES TO PREPARE DINNER FOR GUESTS AT YOUR HOME, WHAT WOULD YOU PREPARE?
> Pepperoncini and a green salad

WHAT IS YOUR TYPICAL BREAKFAST?
> Brown rice, miso soup and seaweed salad

WHAT IS YOUR FAVORITE SNACK?
> Dried tropical fruit

HOW DO YOU UNWIND AFTER A LONG STINT IN THE KITCHEN?
> Take a sauna

WHAT IS YOUR FAVORITE AROMA IN THE KITCHEN?
> The aroma in the pastry room when you are the first one to walk in, early in the morning

IF YOU ONLY HAD $10 TO PURCHASE INGREDIENTS FOR DINNER FOR TWO, WHAT WOULD YOU MAKE?
> Vegetable ratatouille

WHAT IS YOUR STANDARD COMFORT FOOD?
> Sushi

WHAT IS YOUR LEAST-FAVORED VEGETABLE?
> I don't have any

Word to the Wise:

The best way to chop an onion without tears

is to take a bite before chopping.

Index to Restaurants